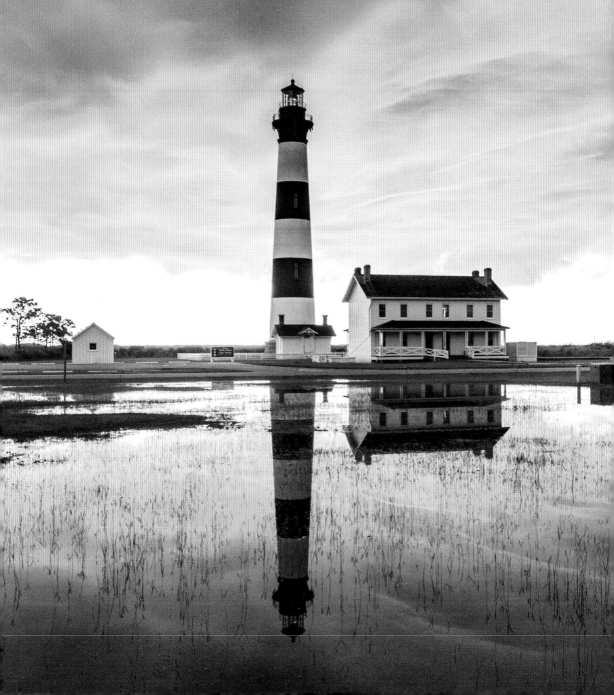

JOURNEY THROUGH

THE OUTER BANKS

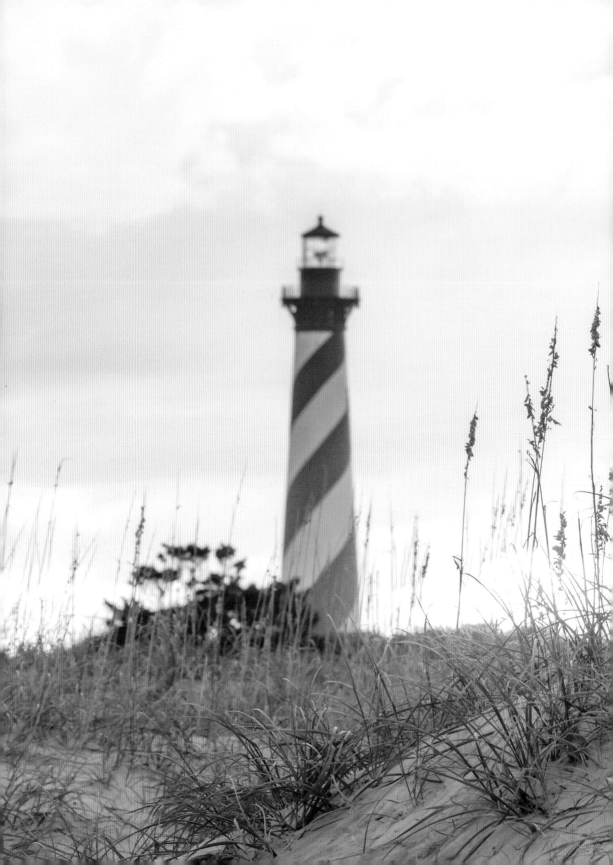

JOURNEY THROUGH

THE OUTER BANKS

WES SNYDER

Globe
Pequot

Guilford, Connecticut

Globe
Pequot

An imprint of The Rowman & Littlefield Publishing Group, Inc.
4501 Forbes Blvd., Ste. 200
Lanham, MD 20706
www.rowman.com

Distributed by NATIONAL BOOK NETWORK

British Library Cataloguing in Publication Information available
Library of Congress Control Number: 2020932493

ISBN 978-1-4930-4893-9 (cloth : alk. paper)
ISBN 978-1-4930-4894-6 (electronic)

∞ The paper used in this publication meets the minimum requirements of American National Standard for Information Sciences—Permanence of Paper for Printed Library Materials, ANSI/NISO Z39.48-1992.

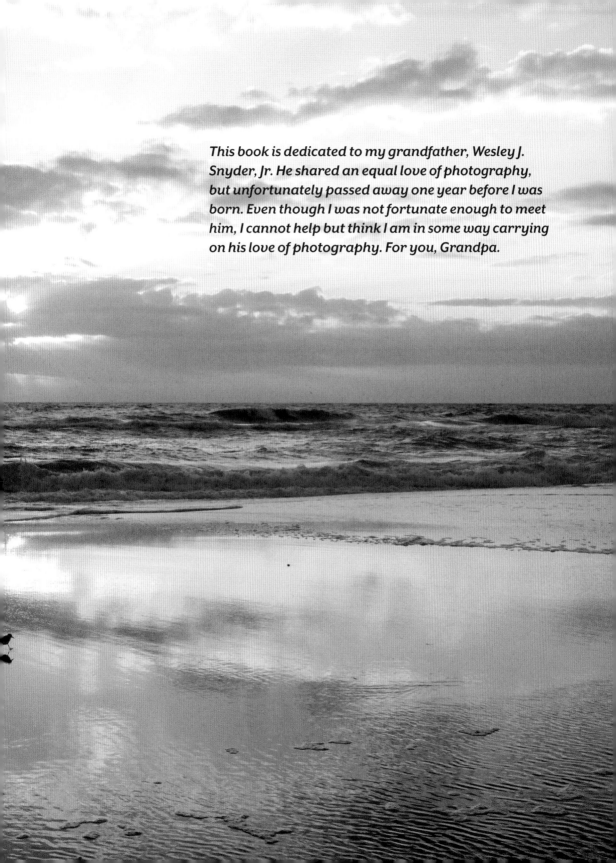

This book is dedicated to my grandfather, Wesley J. Snyder, Jr. He shared an equal love of photography, but unfortunately passed away one year before I was born. Even though I was not fortunate enough to meet him, I cannot help but think I am in some way carrying on his love of photography. For you, Grandpa.

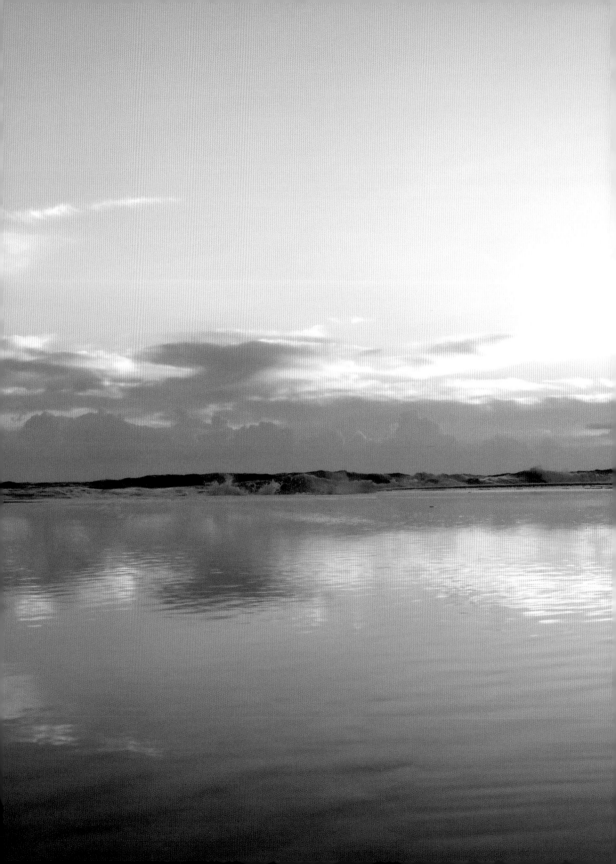

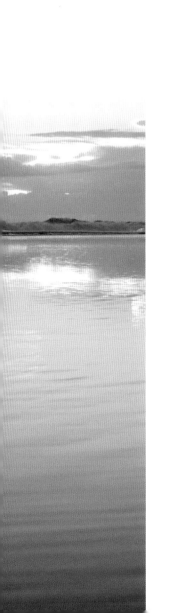

Contents

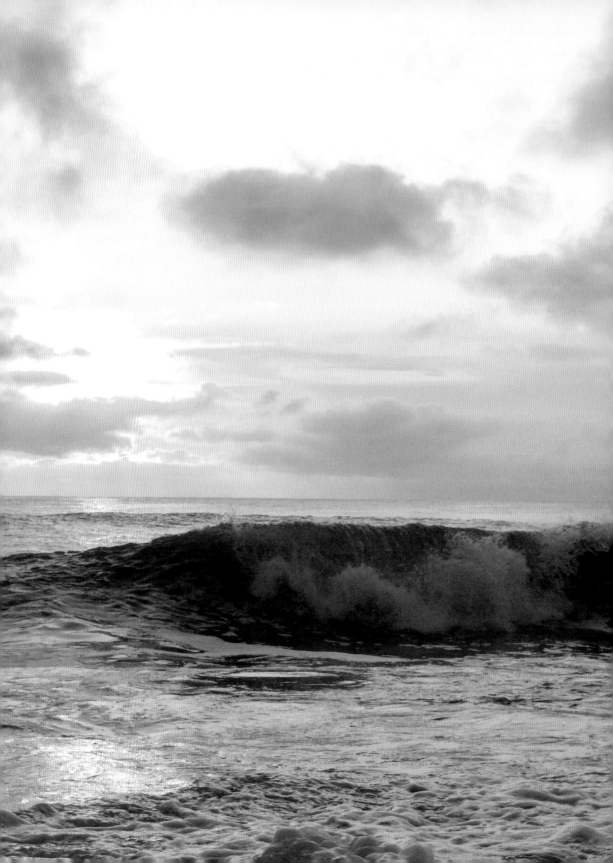

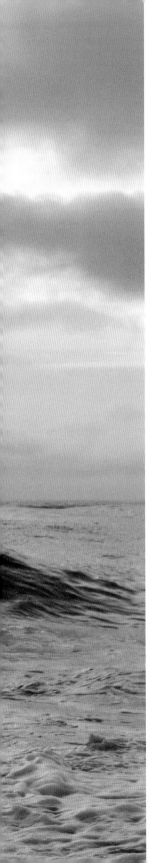

Introduction

Welcome to the Outer Banks of North Carolina.

Bridges and beaches connect this small strip of barrier islands, threading together diverse communities, cultures, and memories. History, geography, and people have made each island distinct. Today, the Outer Banks is comprised of three main regions: Northern Outer Banks, Roanoke Island, and Southern Outer Banks.

The Northern beaches stretch from Carova to Nags Head, with each town hosting a variety of unique shops and restaurants, not to mention the Wright Brothers Museum and herds of wild horses.

Roanoke Island is situated between the mainland and barrier islands, just west of Nags Head. The island was home to the legendary Lost Colony of 1587, still speculated over today. Beyond its murky history, it features a thriving marina, lighthouse, museum and aquarium.

The Southern Outer Banks, also known as Hatteras Island, is the largest of the barriers. This region begins at Oregon Inlet and extends to Ocracoke Island, which is accessible by ferry. Glorious expanses of national seashore make the Southern Outer Banks a top destination for aquatic sports.

These areas are known around the world for their wide scenic beaches, sunrises and sunsets, lighthouses, shipwrecks, wild Spanish Mustang horses, and dark night skies. The islands' rich histories include the Lost Colony of Roanoke, the Wright Brothers' first flight in 1903, and the thousands of shipwrecks that line the coastline, giving the Outer Banks the nickname "Graveyard of the Atlantic."

The islands of the Outer Banks also offer vast stretches of protected beaches devoted to wildlife, sea grasses, sand dunes, and countless varieties of marine life that call the islands their home. These preserved and undeveloped areas of the Outer Banks not only allow local wildlife to thrive, but give residents and visitors a special place to relax, with star-filled night skies that cannot be found anywhere else on the East Coast.

Wes Snyder
photography

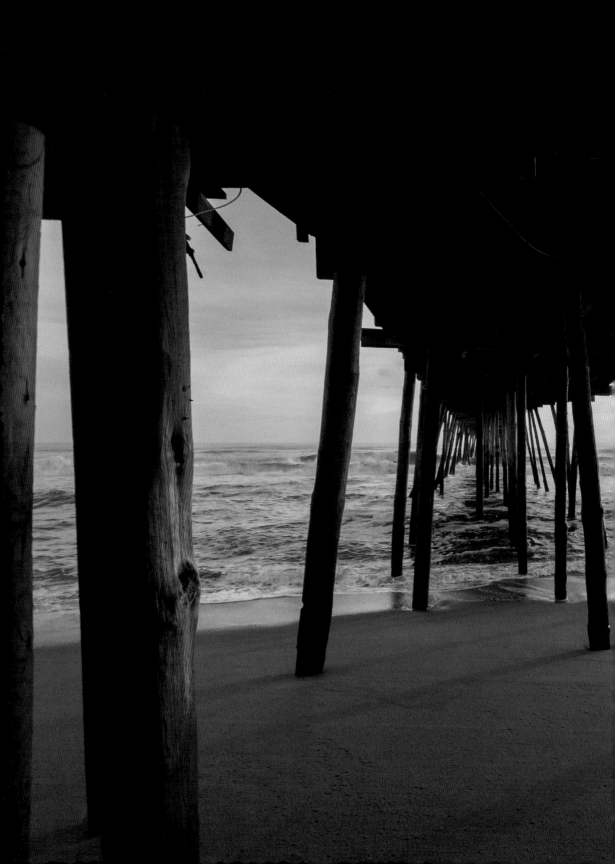

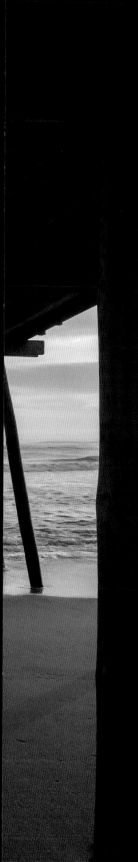

Northern Outer Banks

The northern portion of the Outer Banks runs from northernmost Carova to Nags Head.

Carova is only accessible by 4x4 vehicles, with many retreating here for the solitude and peace.

Corolla is home to the Currituck Beach Lighthouse, whose first lighting was in 1875. It continues to serve as a navigational aid to this day; its brief, 20-second flash cycles can be seen for up to 18 nautical miles from dusk to dawn. Even more anticipated by visitors is a sighting of the wild Spanish Mustangs. Those visiting can take a wild horse tour with Outer Banks Wild Horse Adventures to catch a glimpse of the descendants of the original Colonial Spanish horses.

The towns of Duck and Southern Shores offer a variety of shops, boutiques, and restaurants that give this area a unique blend of options to explore while visiting.

Beautiful beaches of the north offer a less crowded place to enjoy the sun, sand, and waves.

The last three towns tend to be the most populated during the summer tourist season and thus offer countless opportunities to play, relax, and enjoy the Outer Banks. Kitty Hawk, Kill Devil Hills, and Nags Head offer both oceanfront and soundside areas to explore. In just under ten miles' distance of beach from Kitty Hawk to Nags Head, there are five piers to fish from or simply enjoy the ocean view. Beach and sound excursions are numerous on this stretch of the barrier island. Restaurants for all tastes and souvenir shops line the streets.

Two of the most interesting and visited sites of the Northern Outer Banks are the Wright Brothers Museum and Jockey's Ridge. The former was built in honor of two aviation pioneers, brothers Orville and Wilbur Wright, who made their first powered airplane flight on the beaches at Kitty Hawk in 1903. Meanwhile, the latter is the largest sand dune on the East Coast, a playground for visitors who want to hang glide, sled, or traverse the ever changing dunescape.

Bodie Island Lighthouse is perhaps one of the most visited places of the Northern Outer Banks. Bodie Lighthouse is just south of Nags Head, a short distance from the Oregon Inlet and marina.

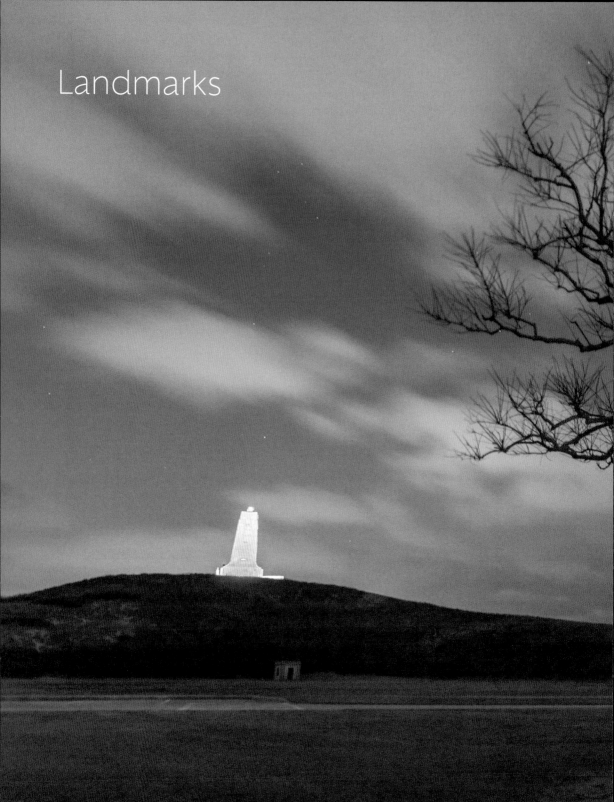

Landmarks

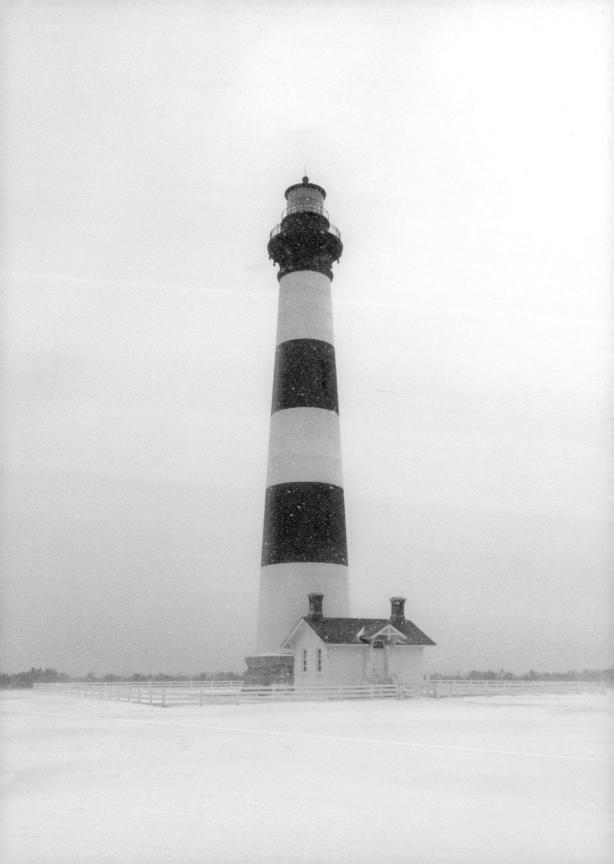

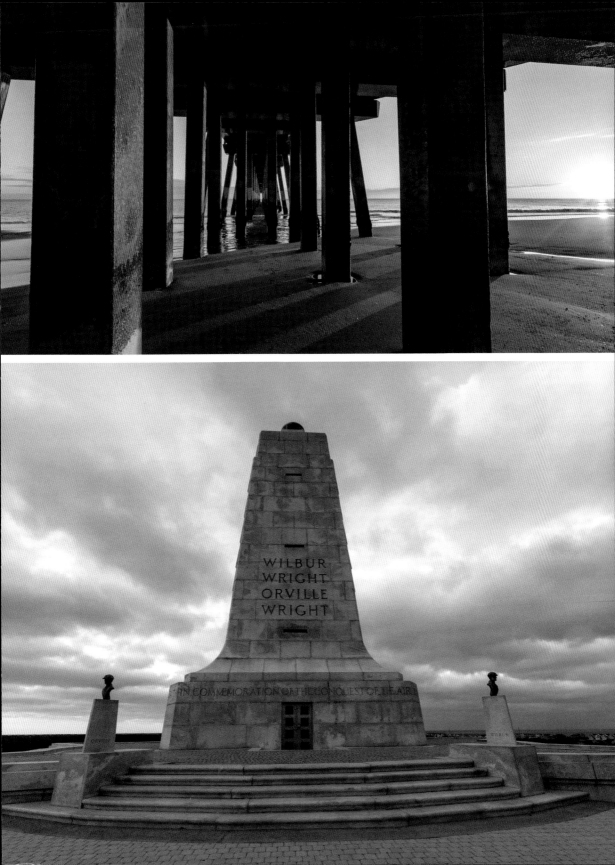

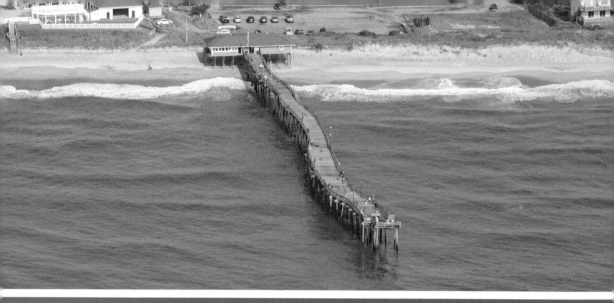

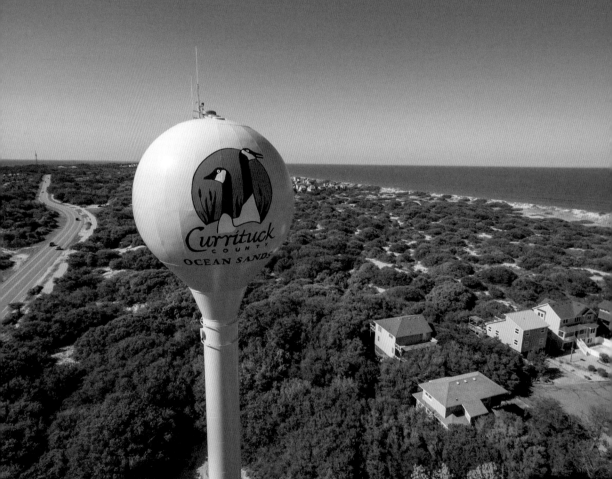

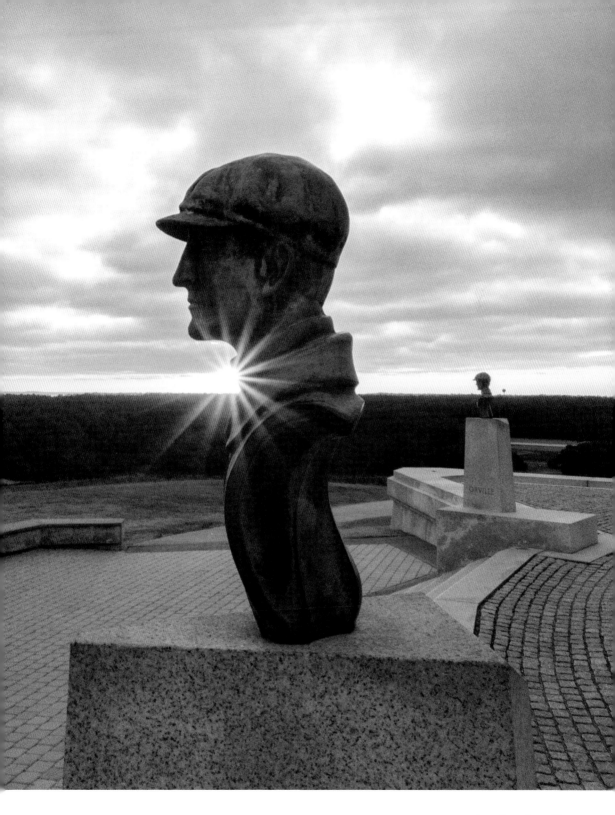

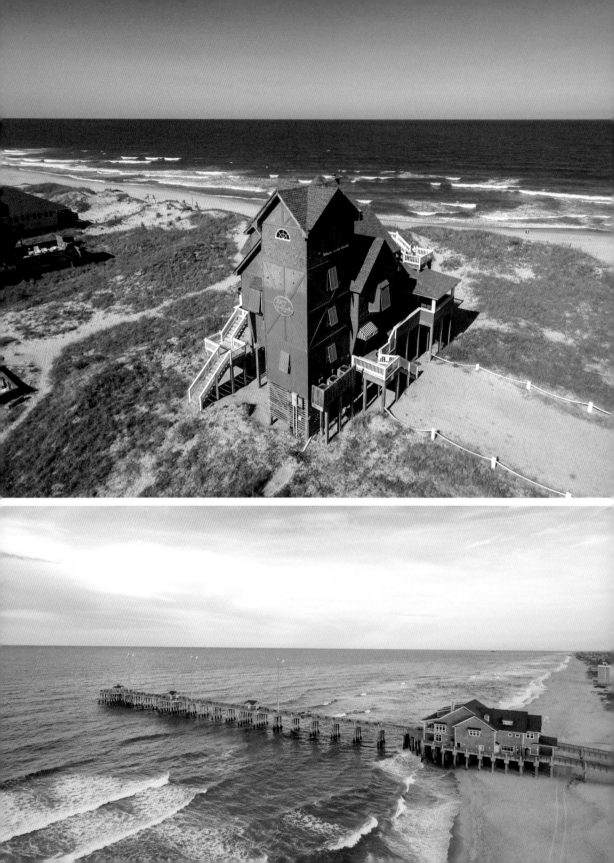

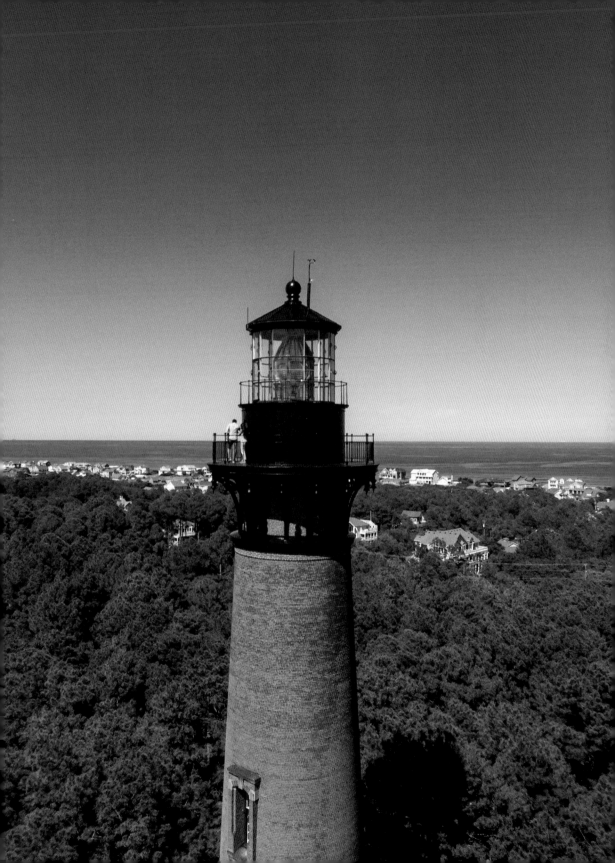

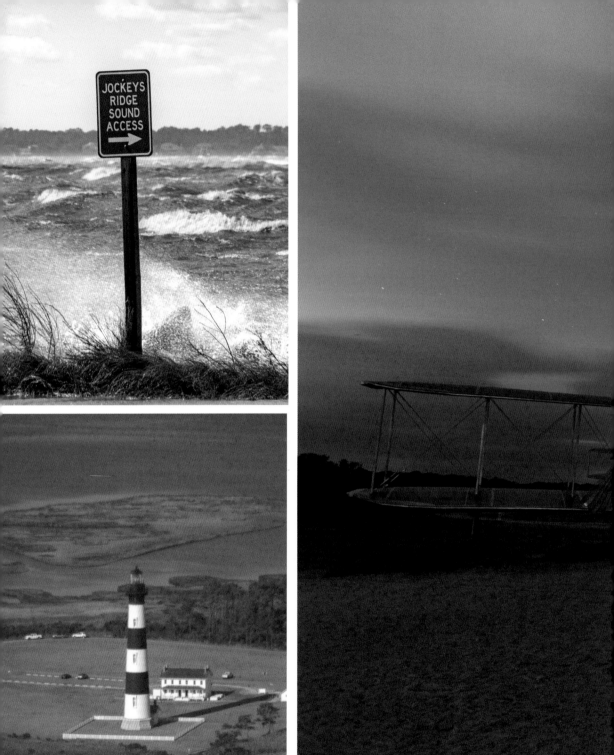

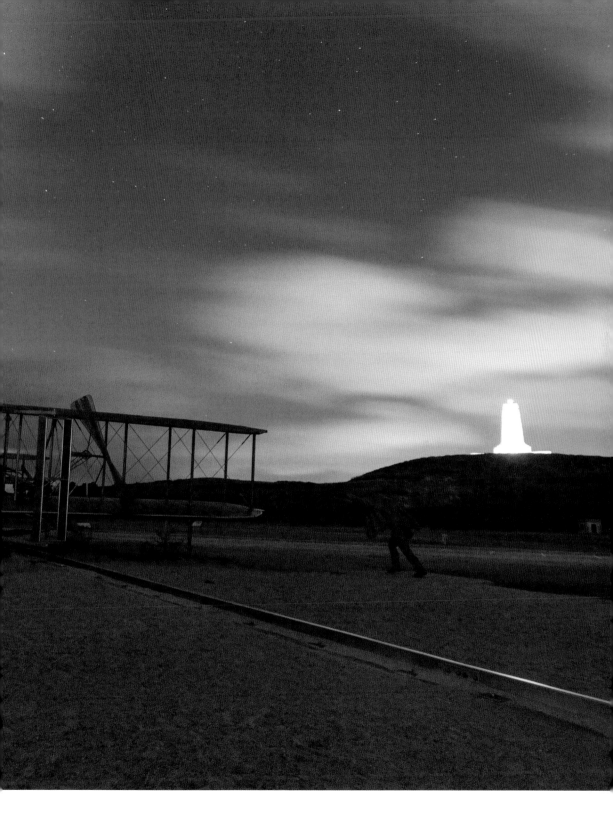

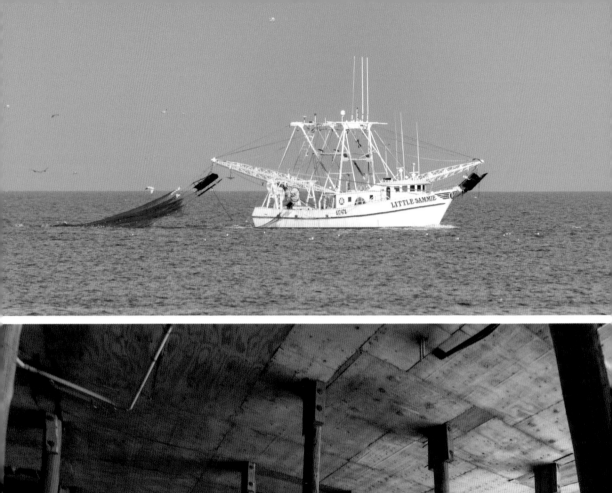
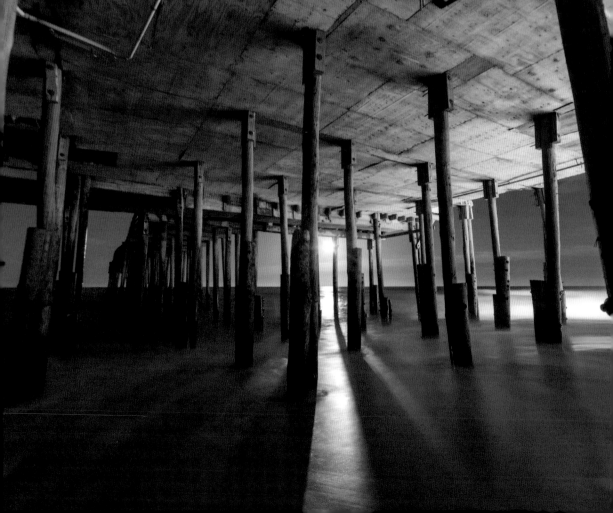

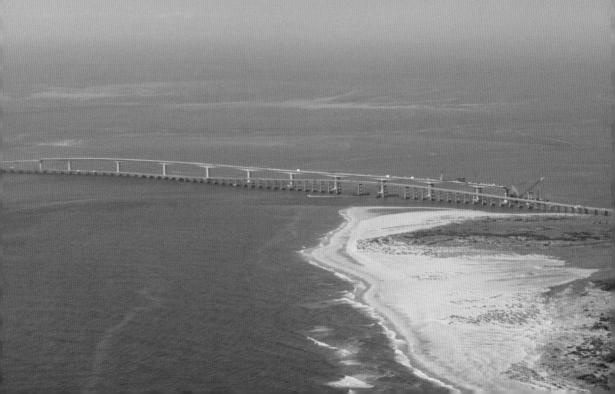

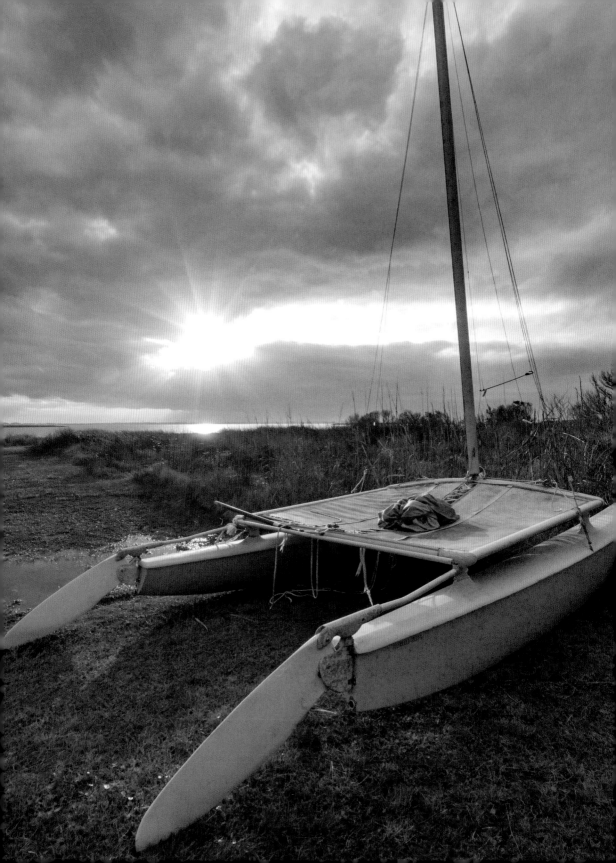

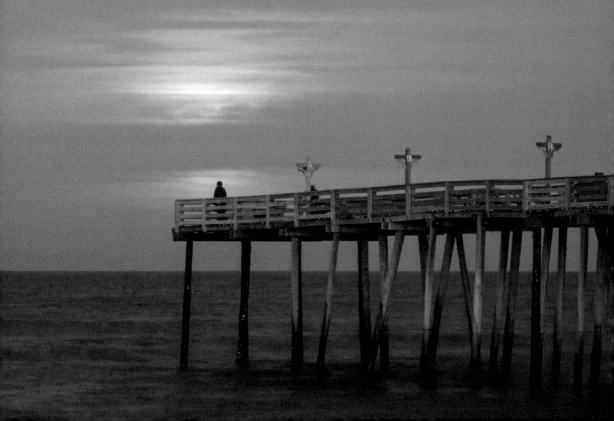

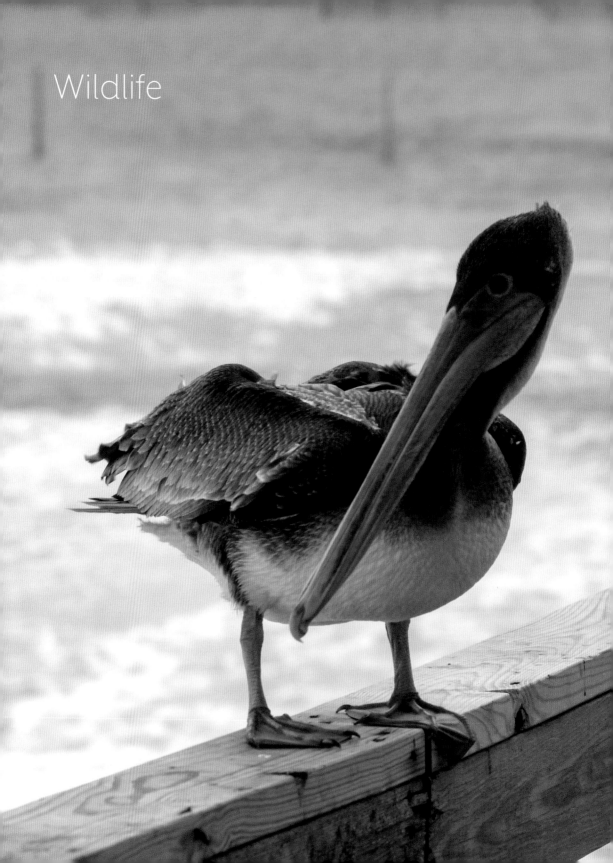

Wildlife

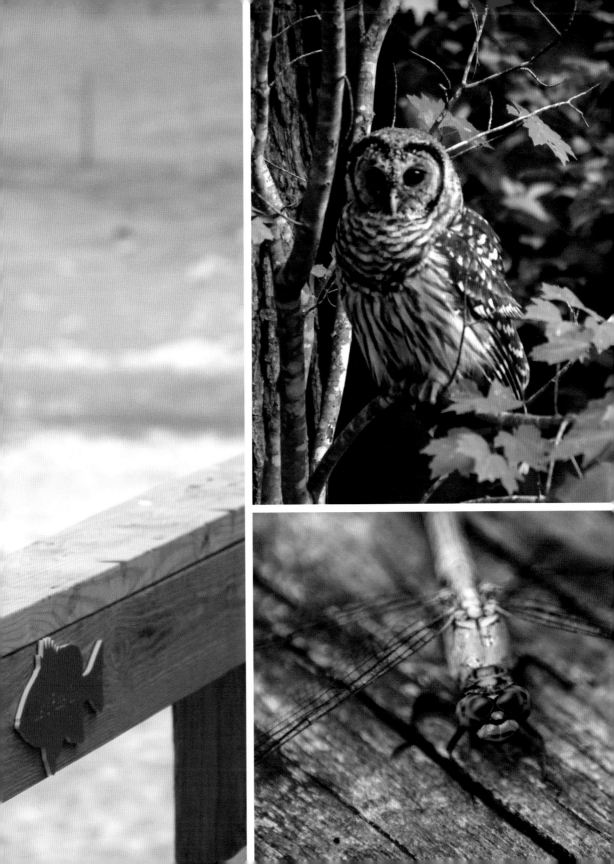

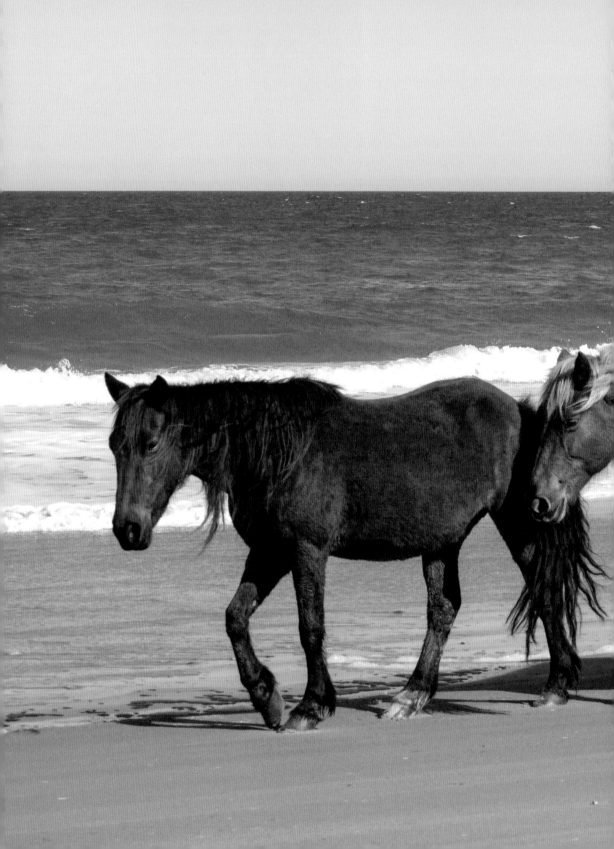

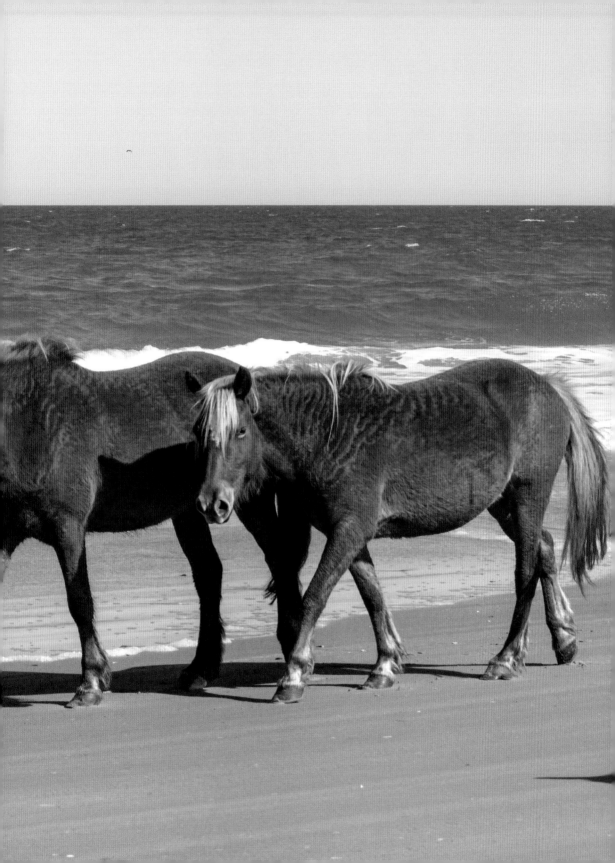

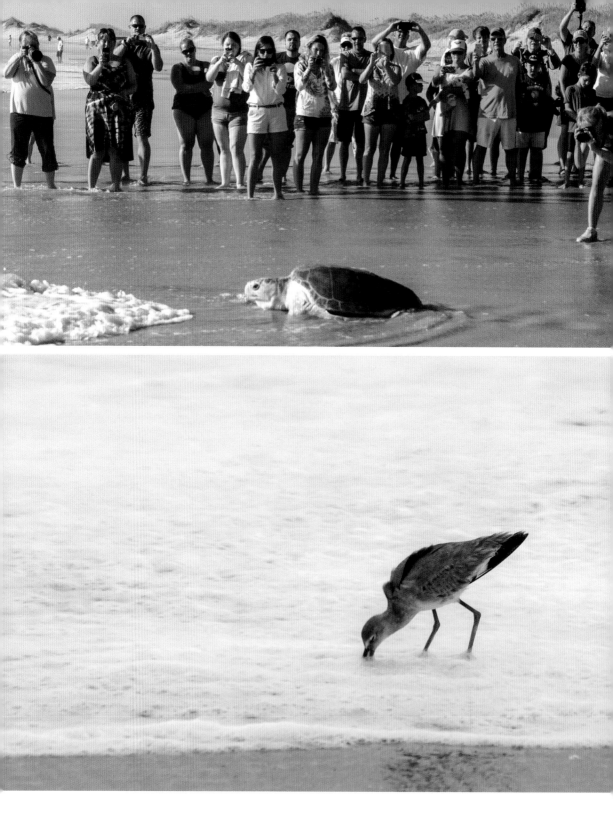

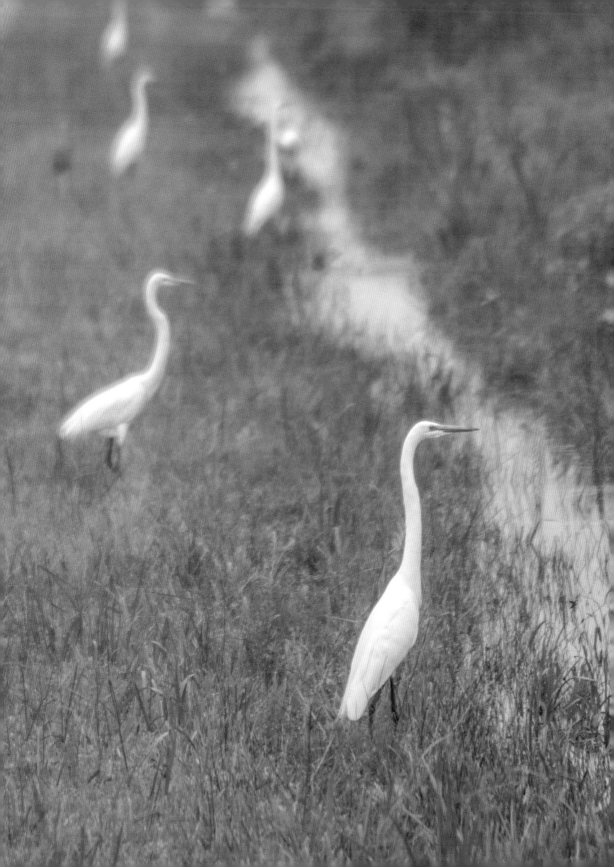

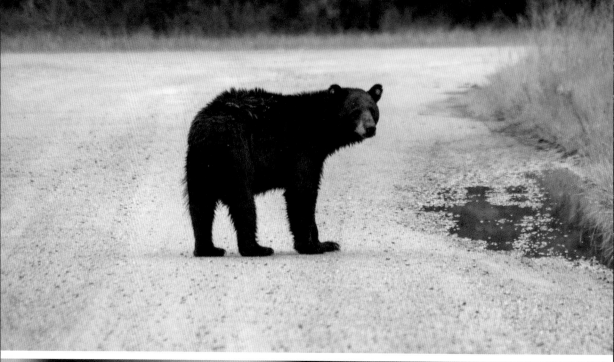

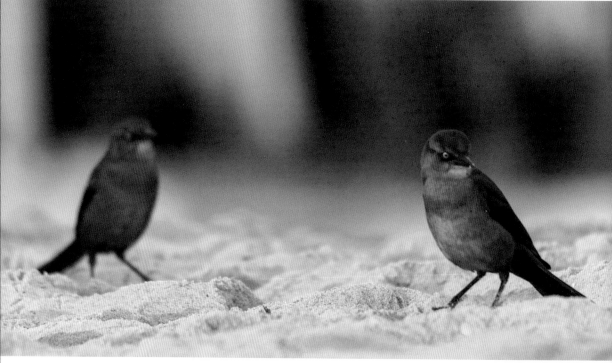

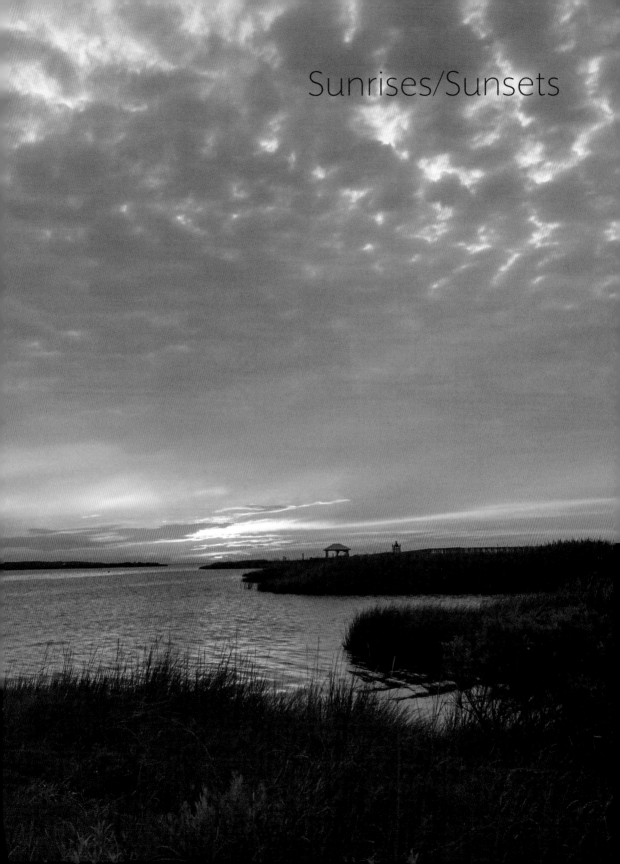

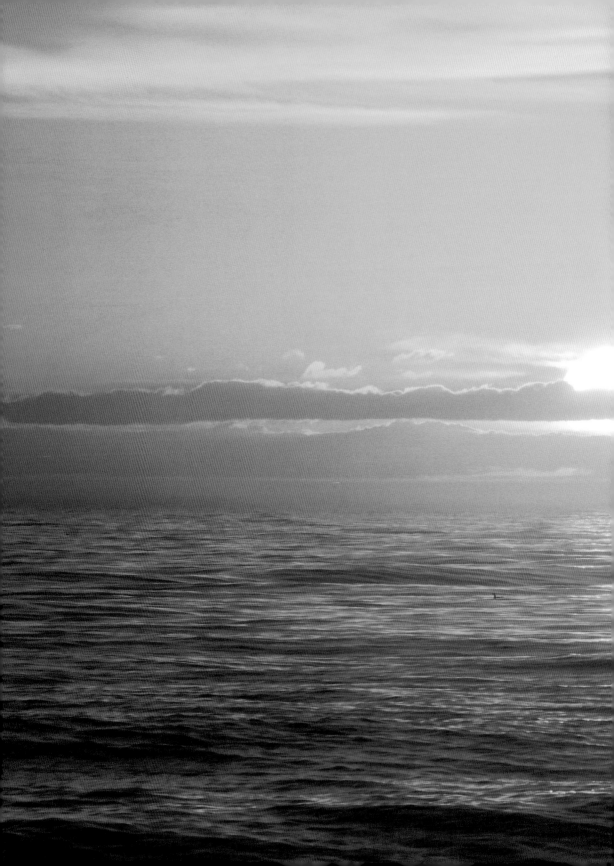

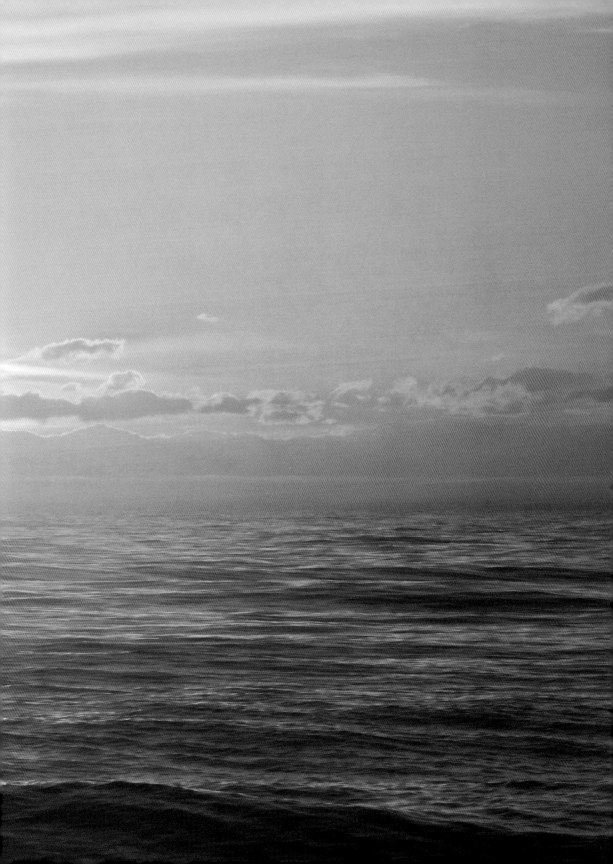

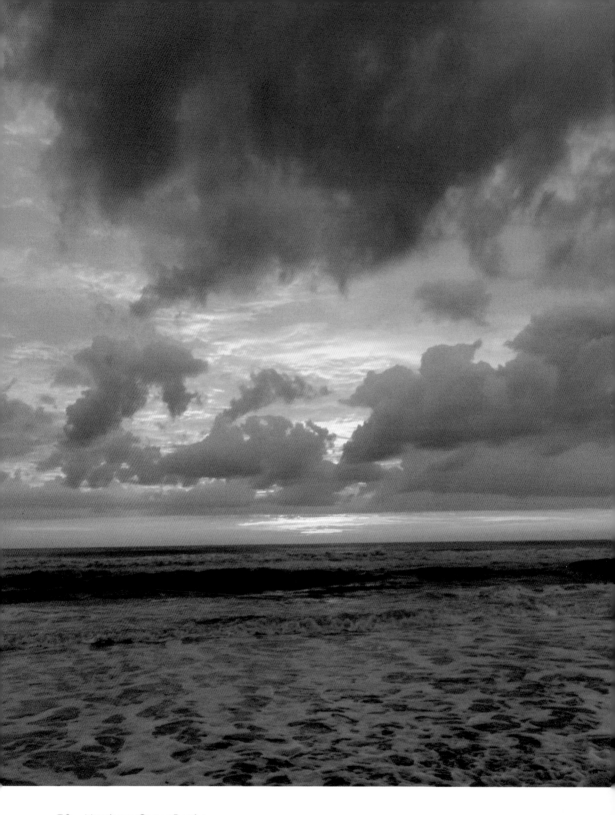

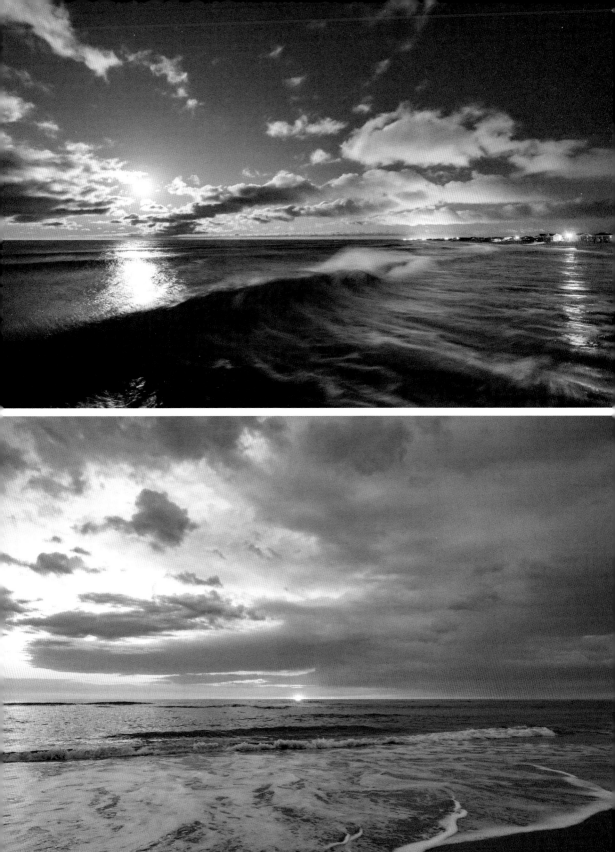

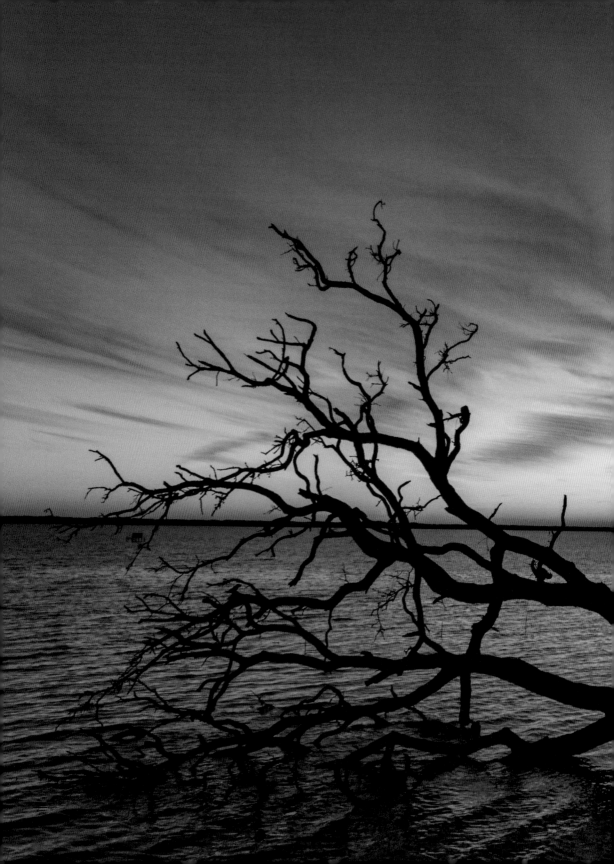

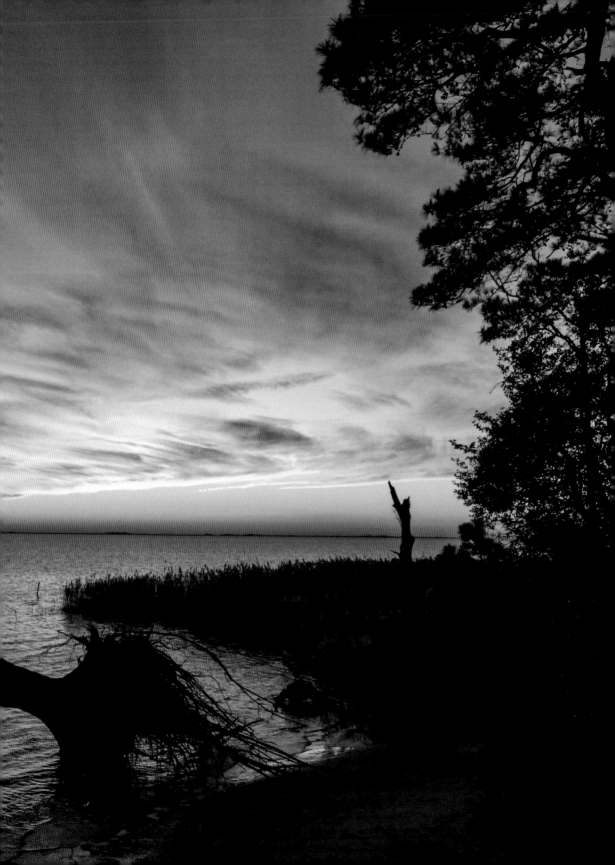

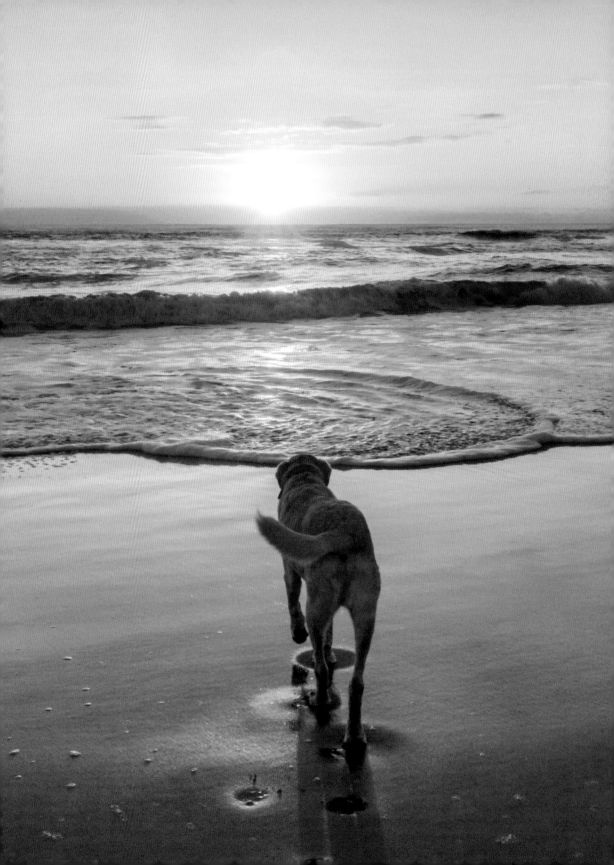

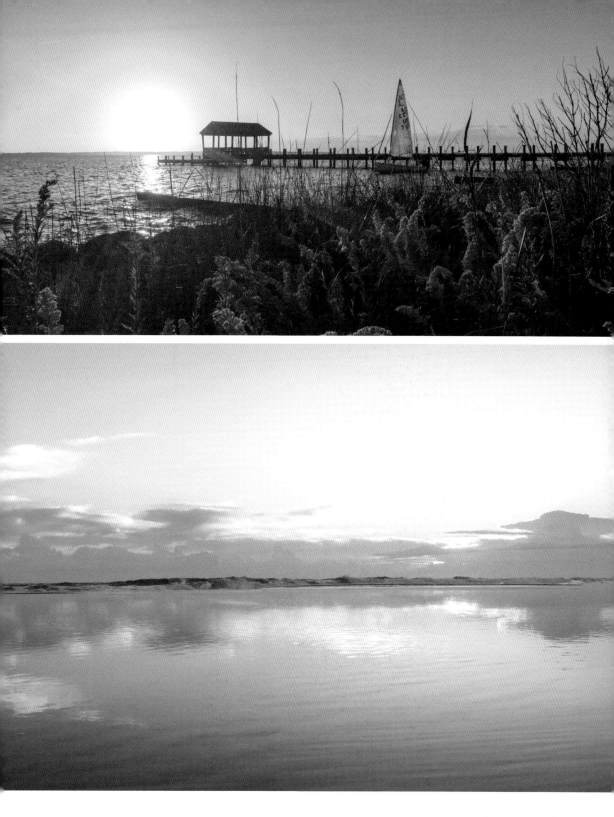

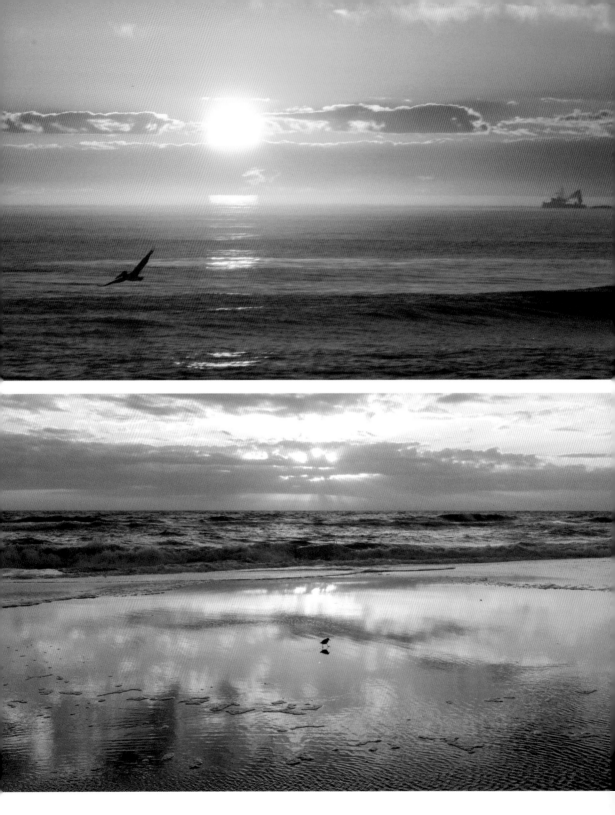

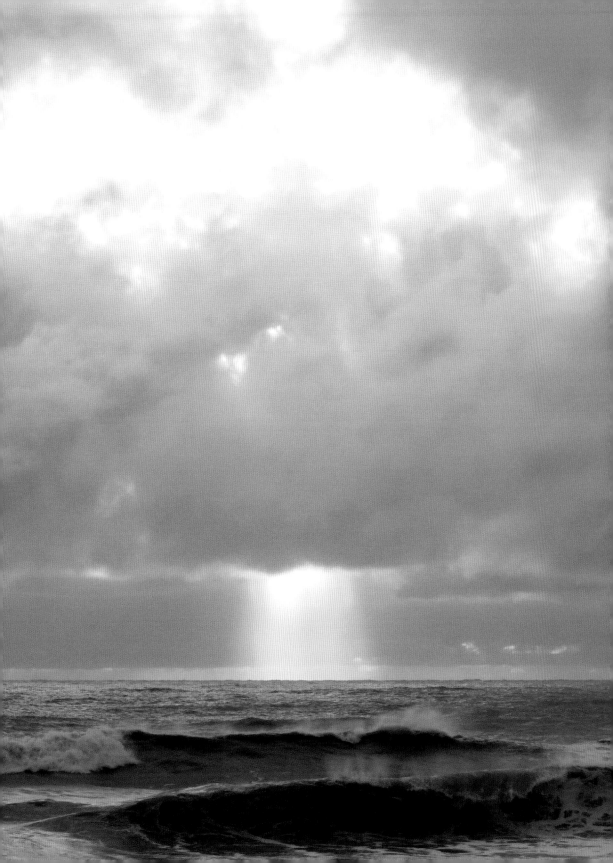

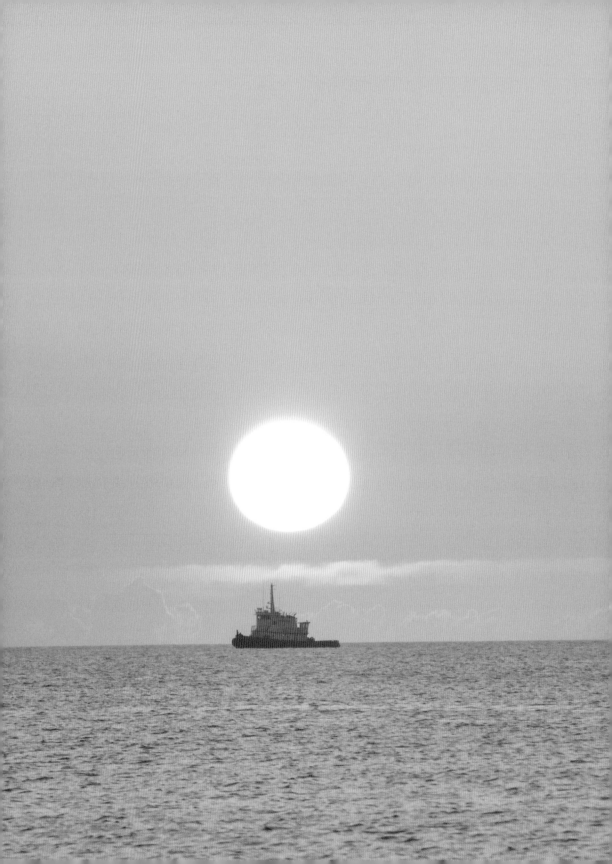

Night Sky

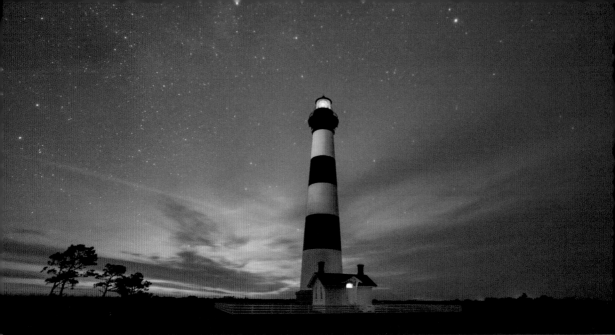

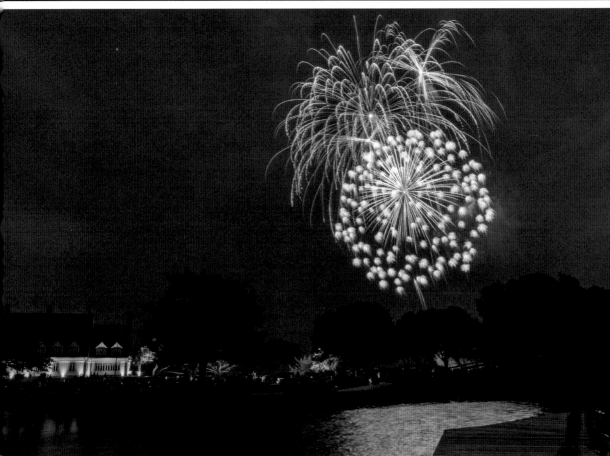

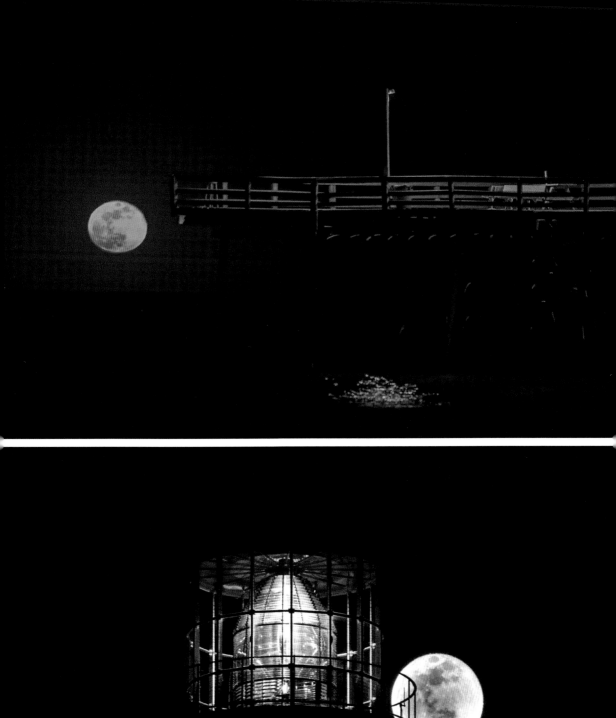

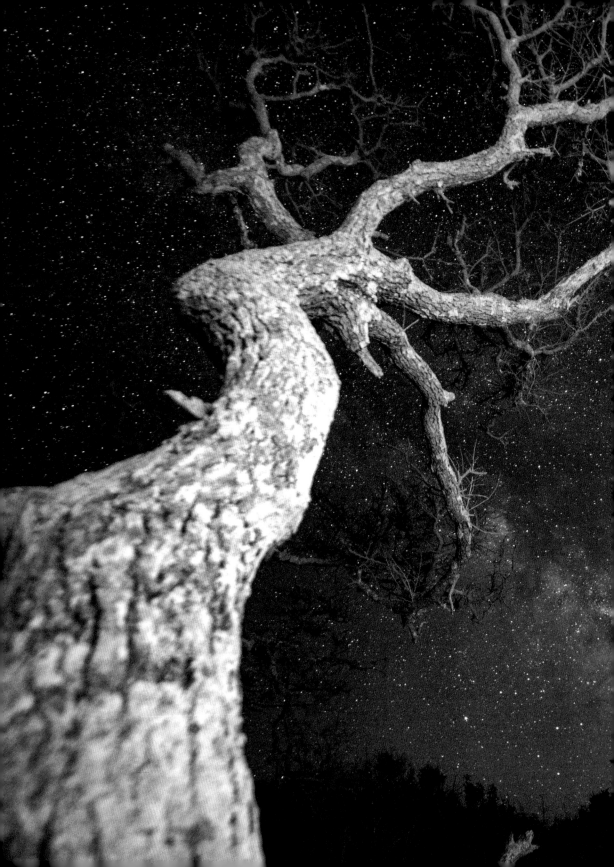

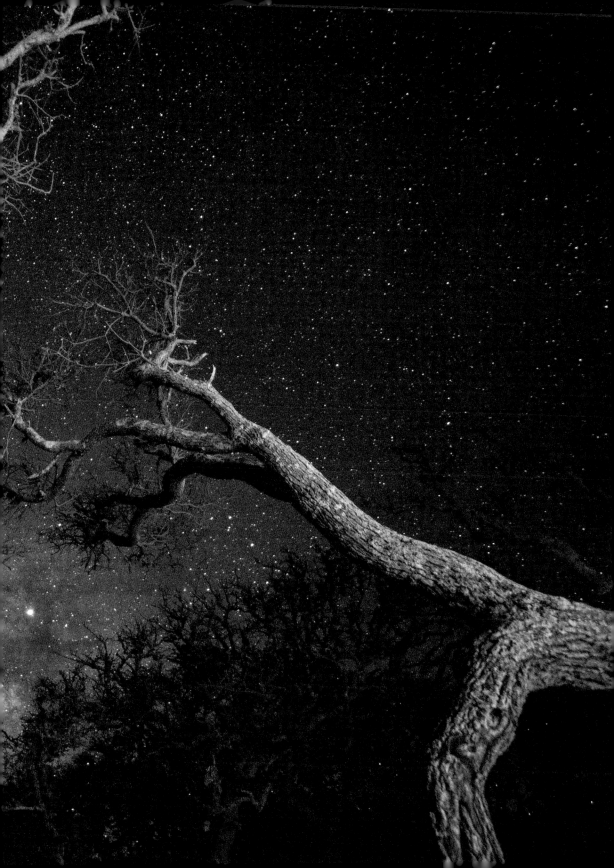

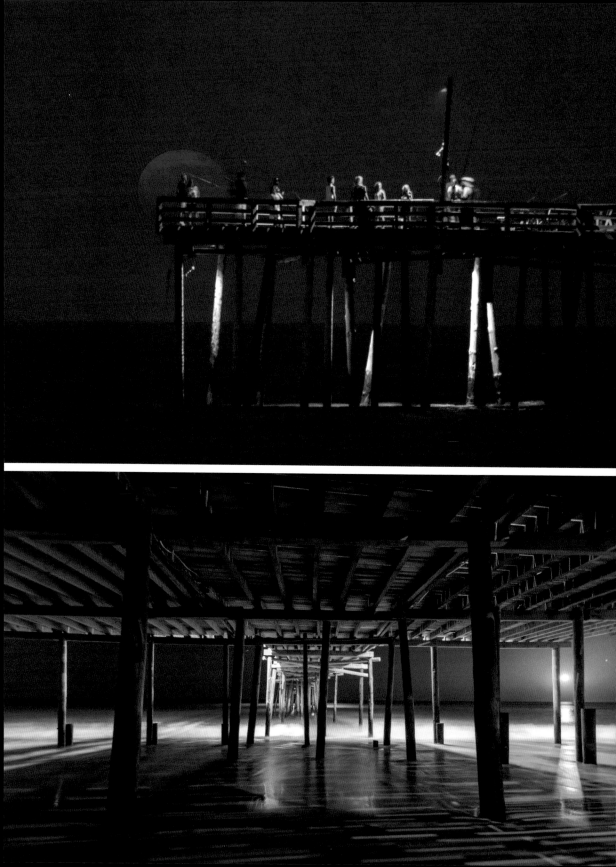

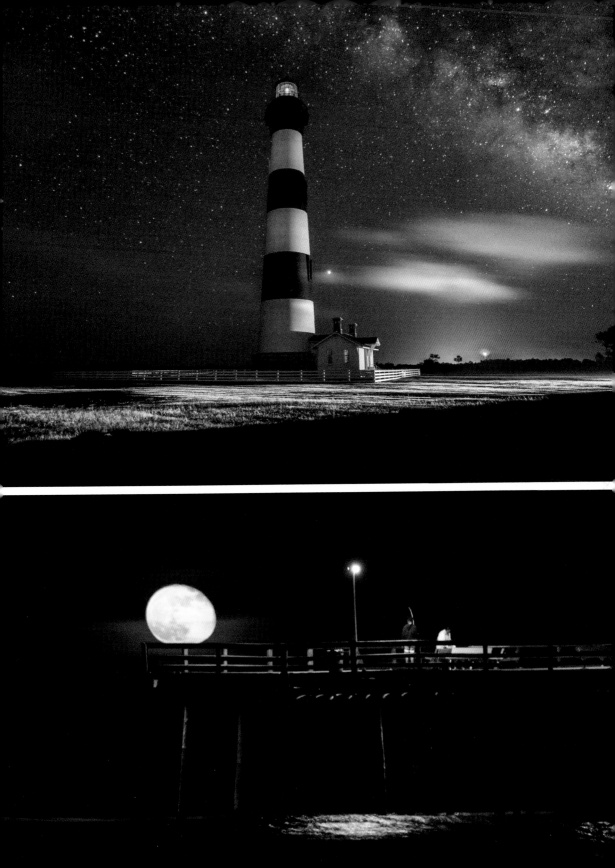

Roanoke Island

Roanoke Island is one of the most distinctive areas along the Outer Banks. The island, just eight miles long and two miles wide, is positioned between Nags Head and the town of Manns Harbor on the mainland. Home to six thousand residents, the island is made up of only two towns named for two Native Americans who lived on the island centuries ago: Wanchese to the south side and Manteo to the north.

Wanchese is recognized as a primary fishing community and supplies much of the seafood sold on the Outer Banks.

Manteo, situated on the north end is much more geared toward tourism, with attractions like the downtown marina, Roanoke Marshes Lighthouse, Fort Raleigh National Historic Site, the Elizabethan Gardens, Island Festival Park, and the North Carolina Aquarium.

What the island lacks in size, it more than makes up for in its rich history, thriving ancient maritime forests, and various local attractions.

Attempts to establish Roanoke began in 1584, but it was not permanently settled until 1587, when nearly one hundred and twenty English colonists made their home at the "Lost Colony." The first English child born on the island was Virginia Dare in August 1587. When John White returned to the colony is 1590, everyone had vanished. The mystery of the colonists' disappearance continues to attract visitors to the island today.

In fact, visitors in the summer can come explore Fort Raleigh National Historic Site and watch the longest-running outdoor drama, *The Lost Colony*, at Manteo's Waterside Theatre. The play teaches visitors more about the original settlers of the island and the mysterious disappearance of the Lost Colony of Roanoke.

Landmarks

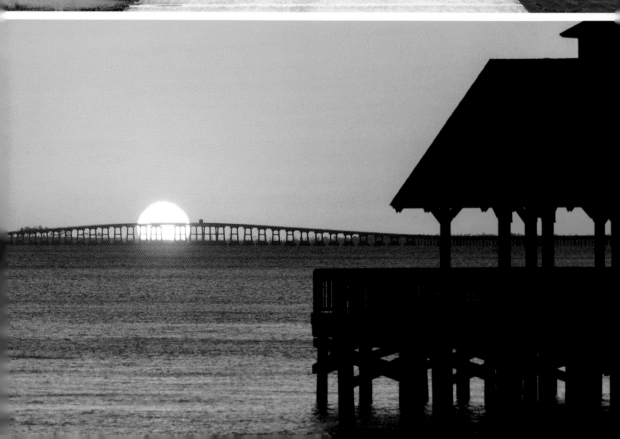

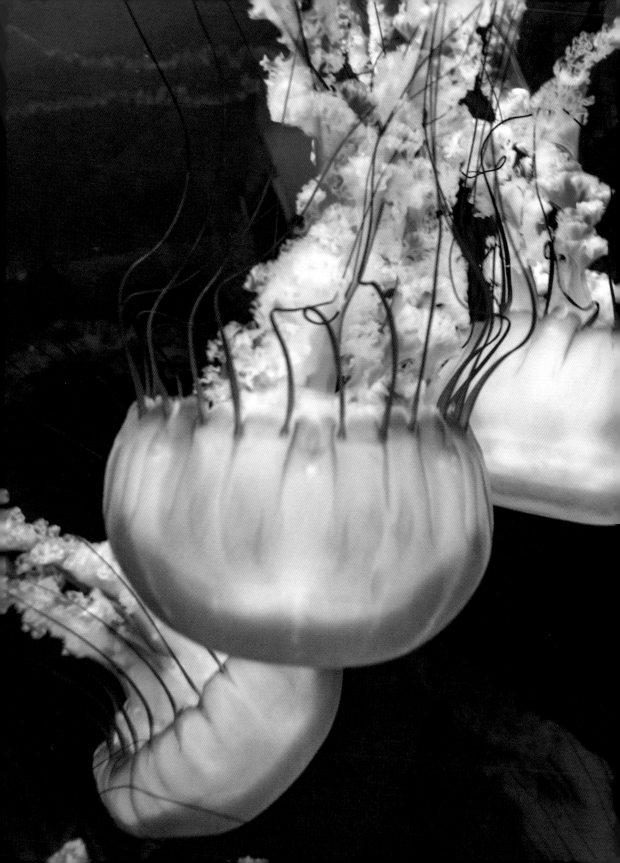

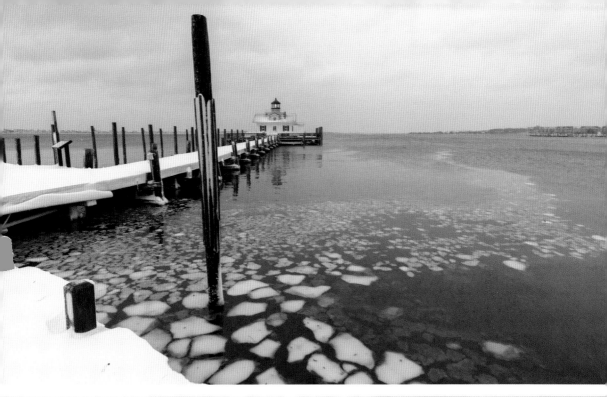

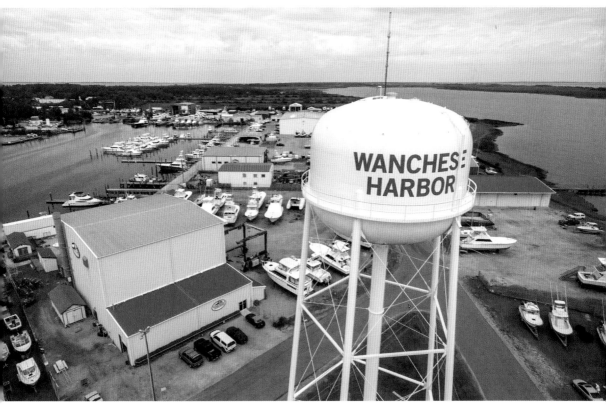

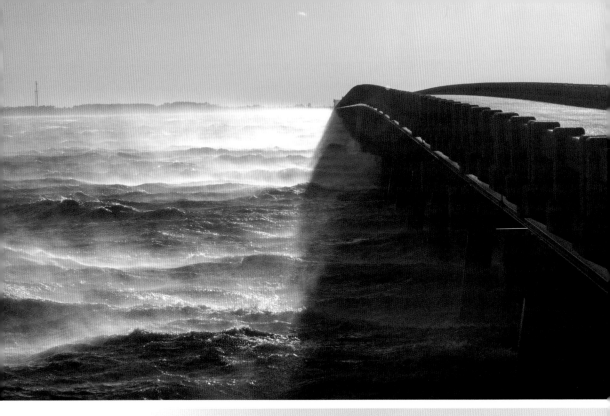

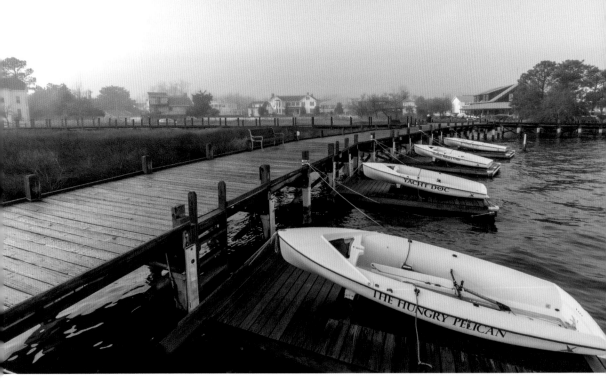

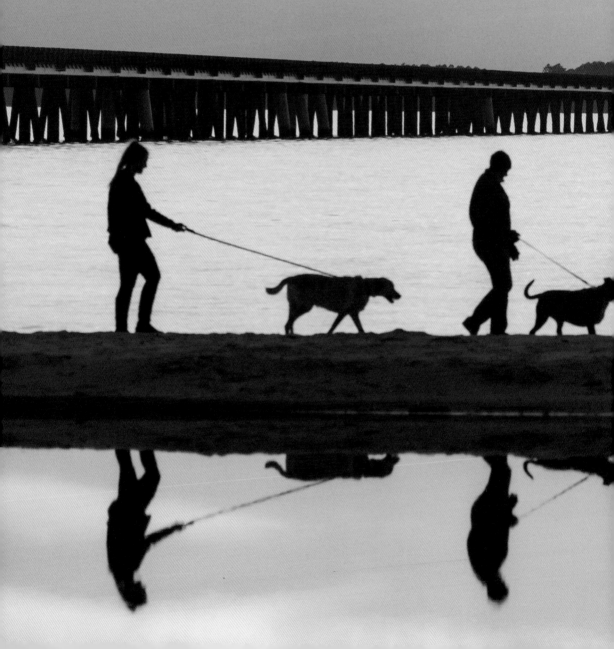

Sunrises/Sunsets

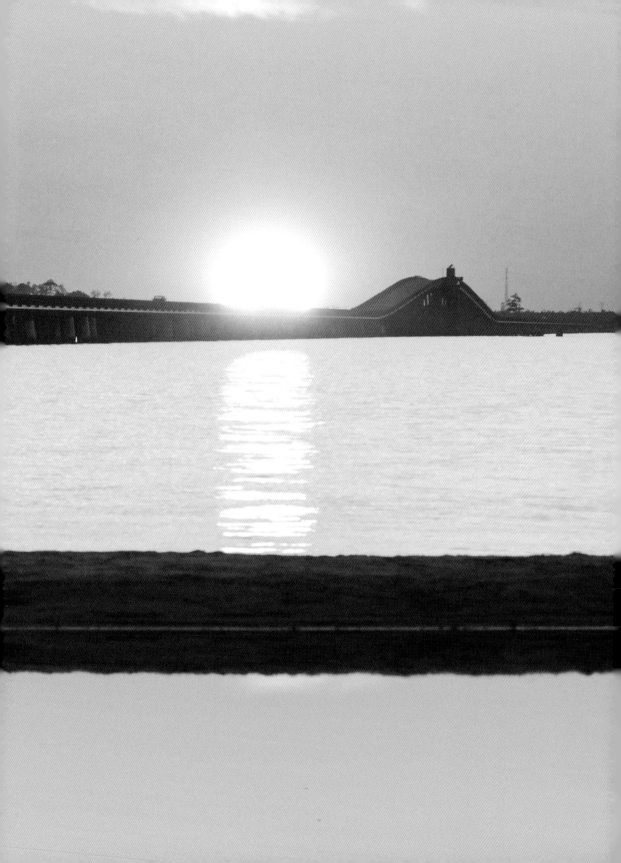

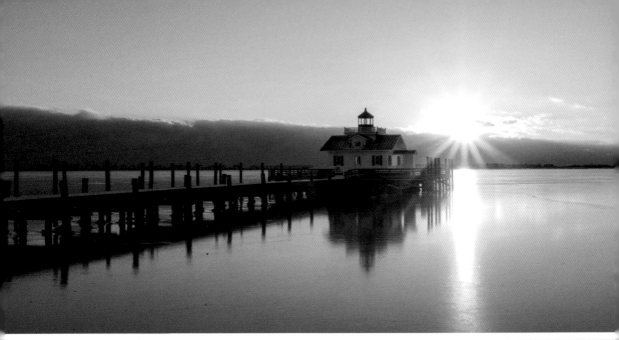

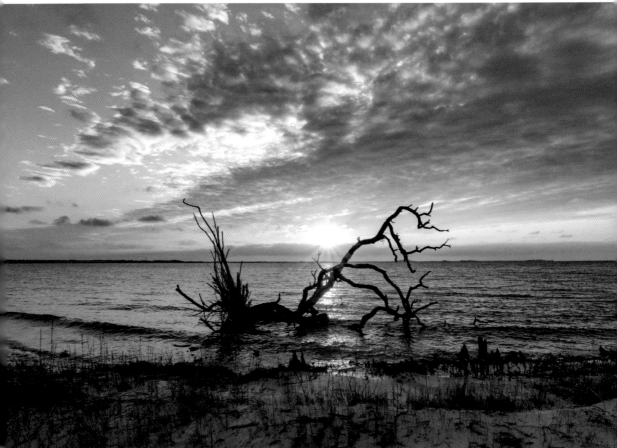

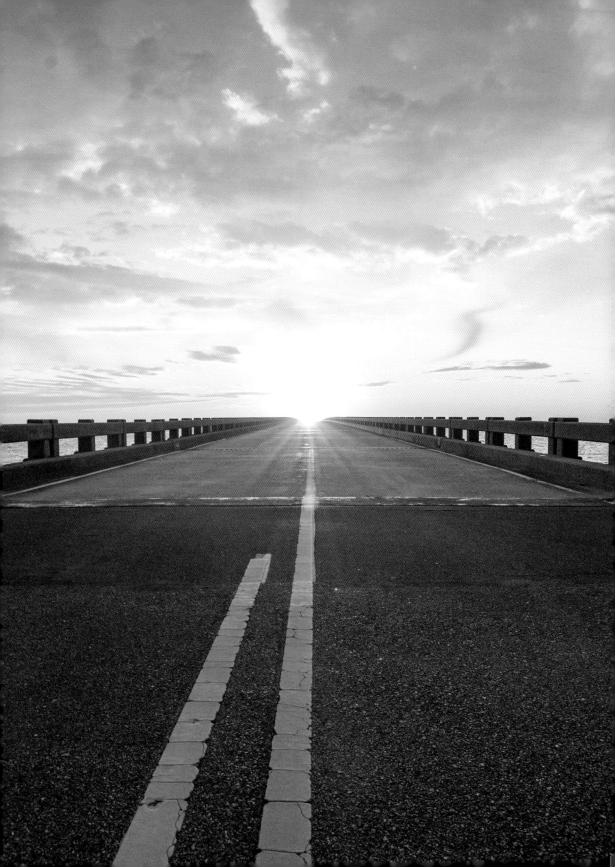

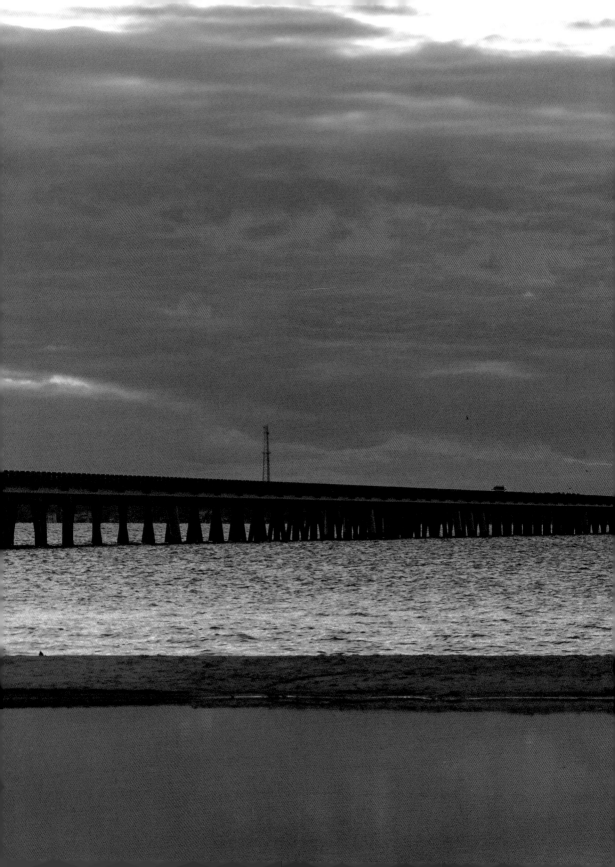

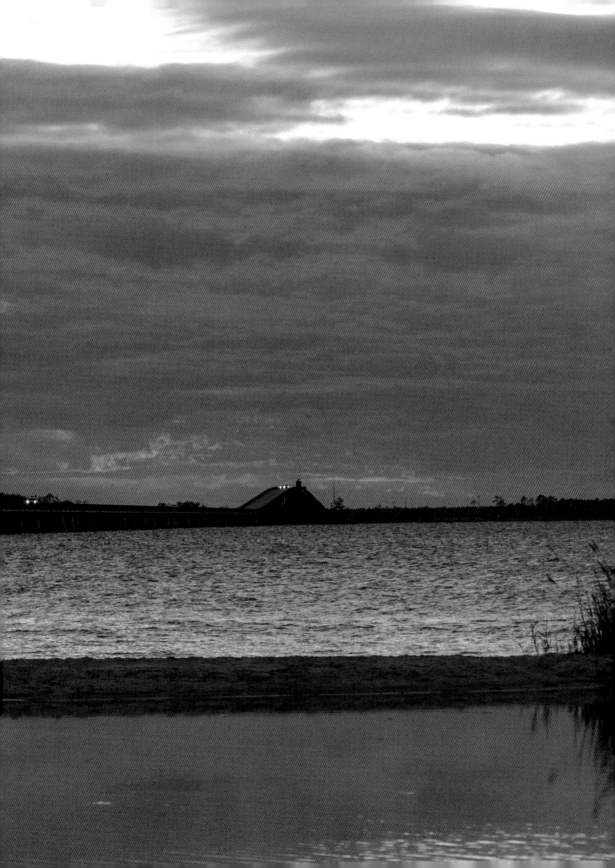

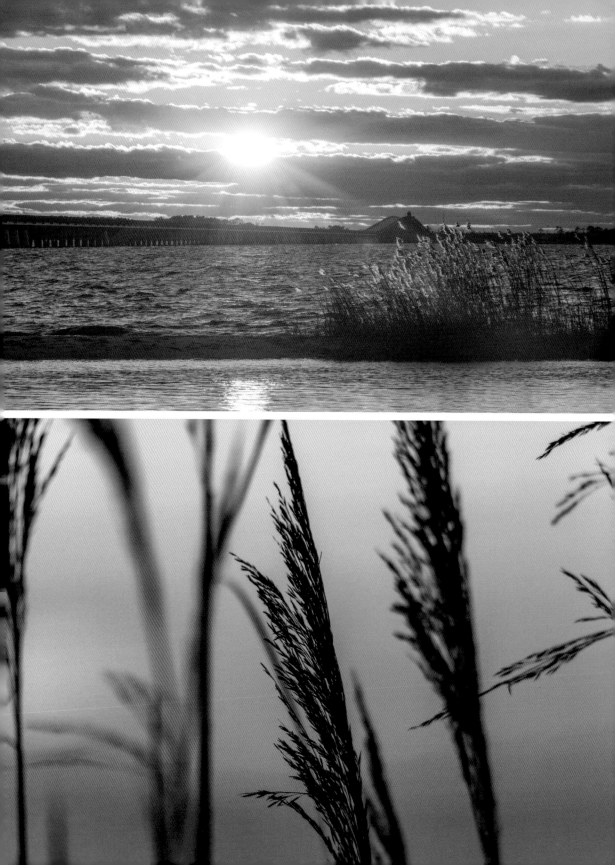

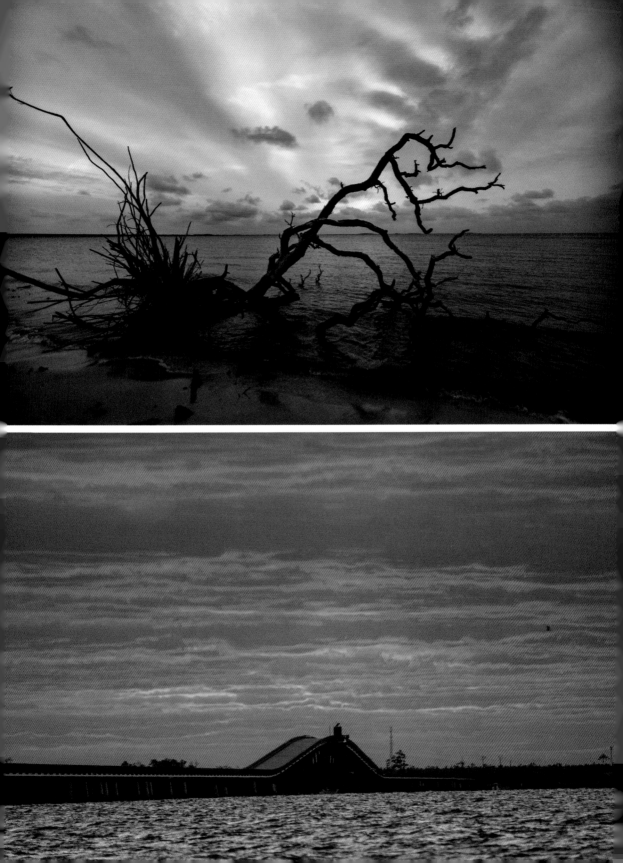

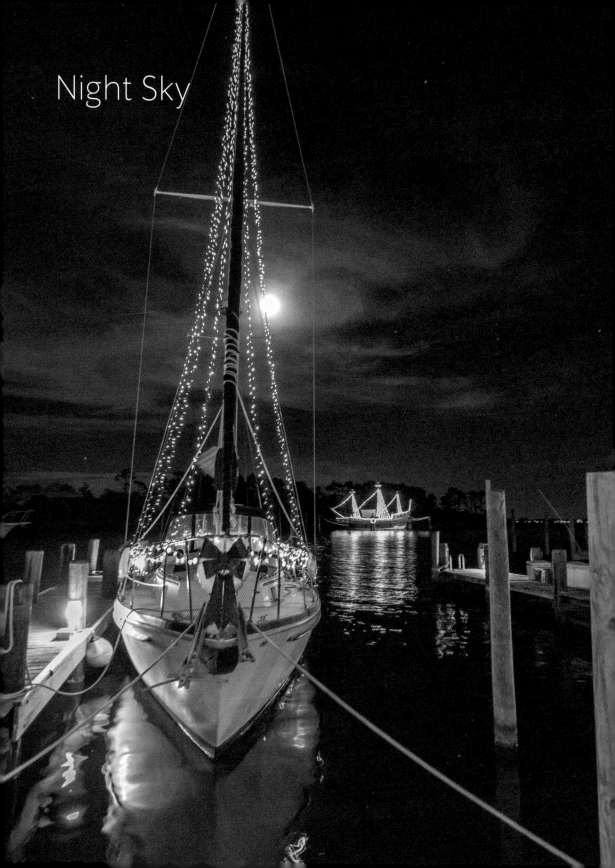

Night Sky

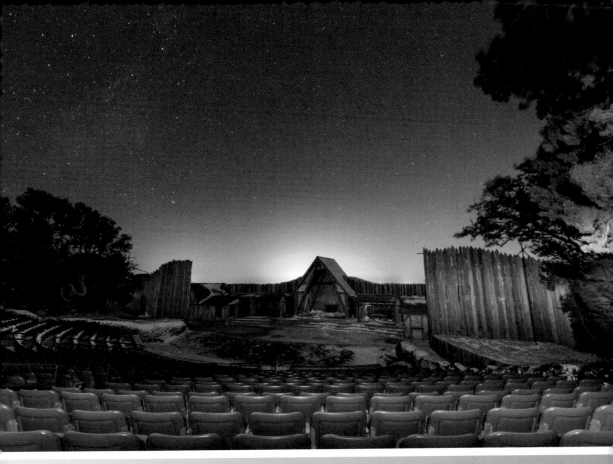

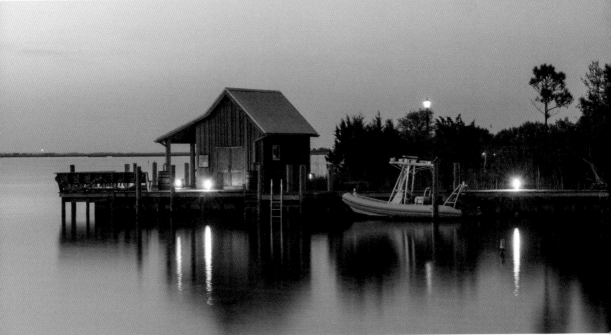

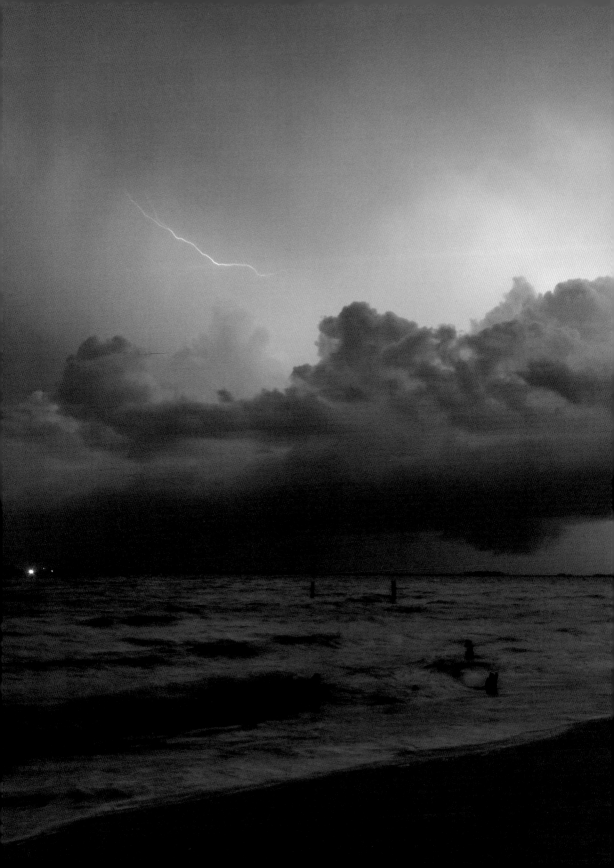

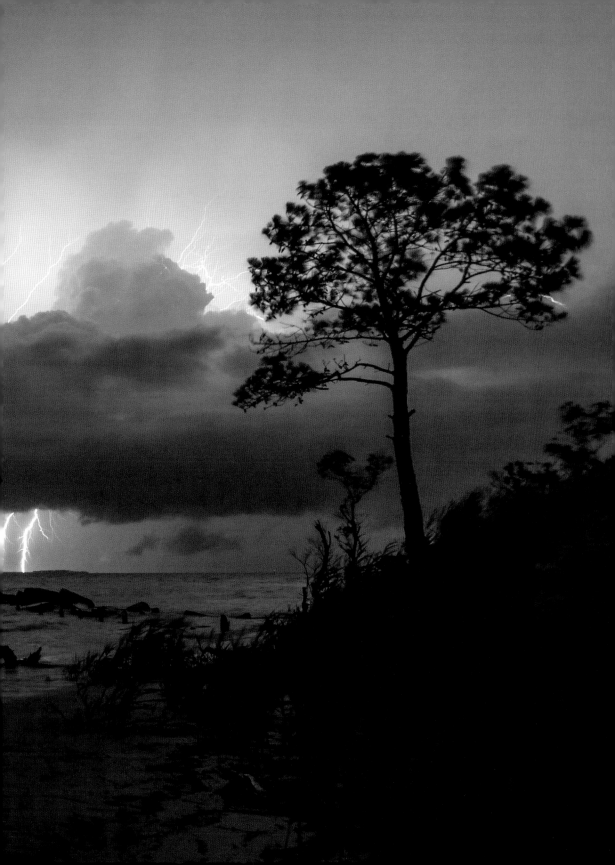

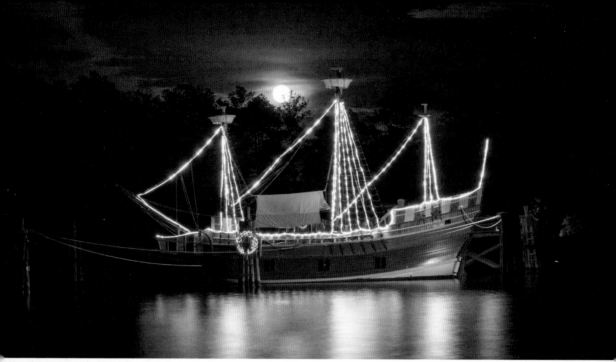

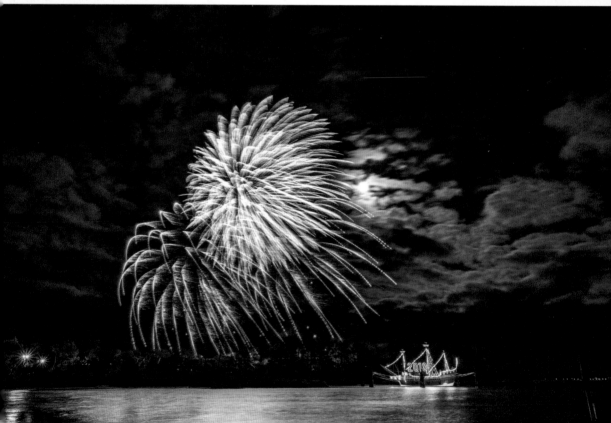

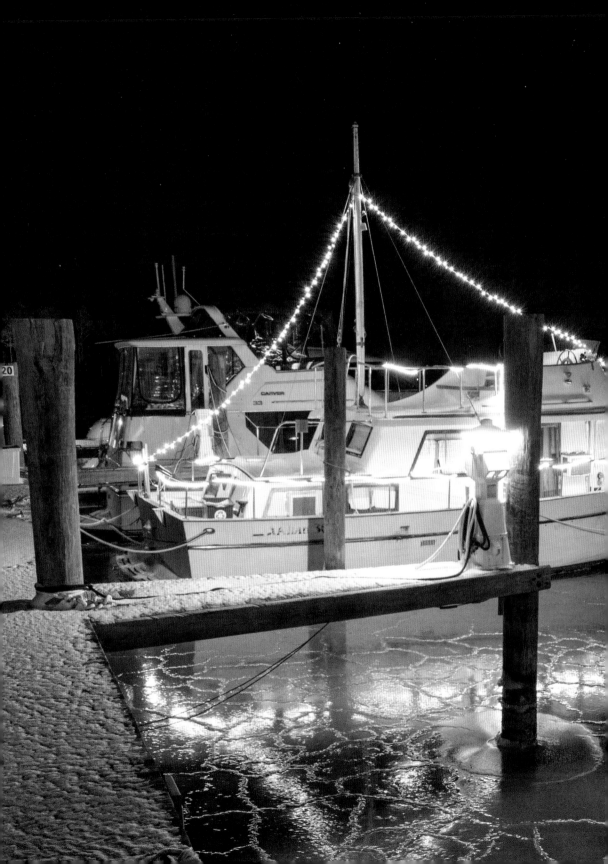

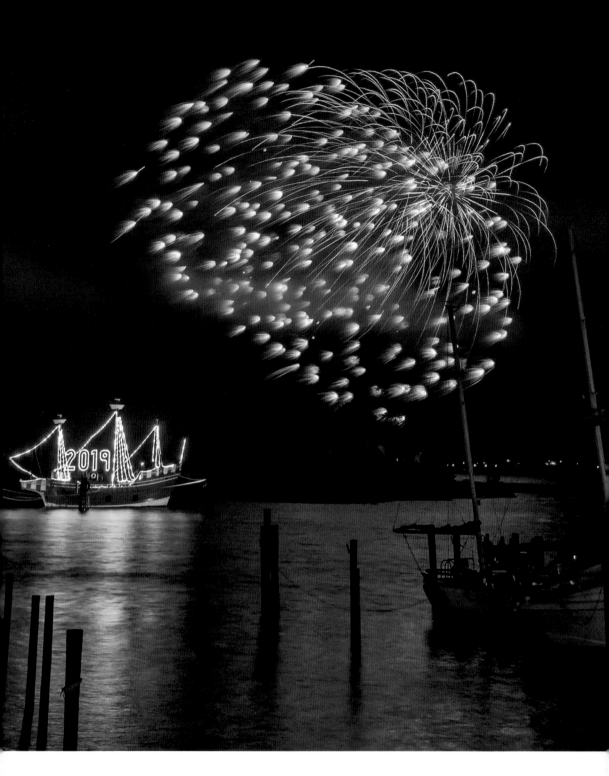

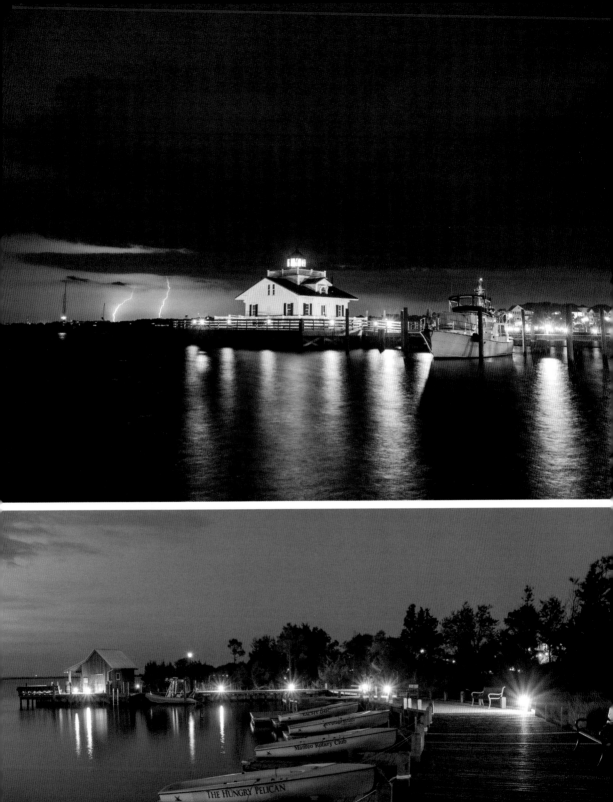

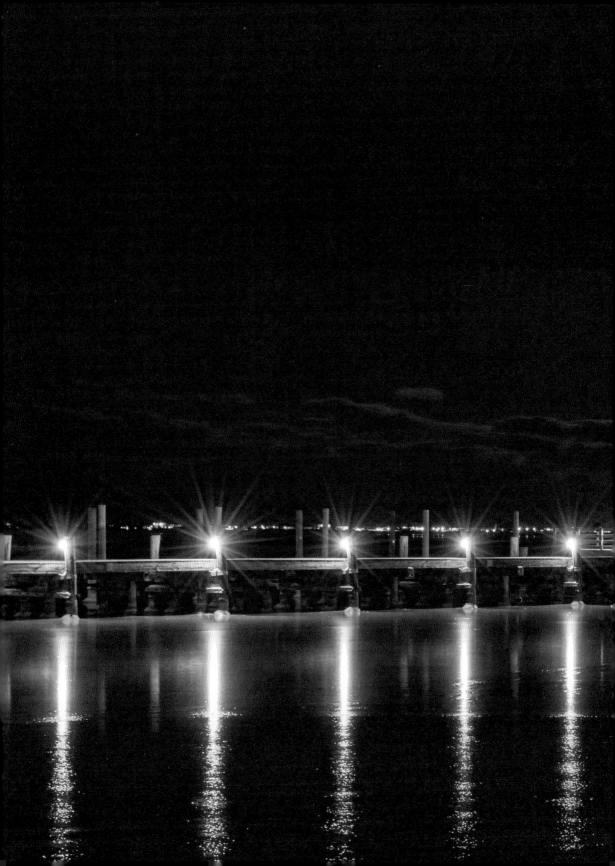

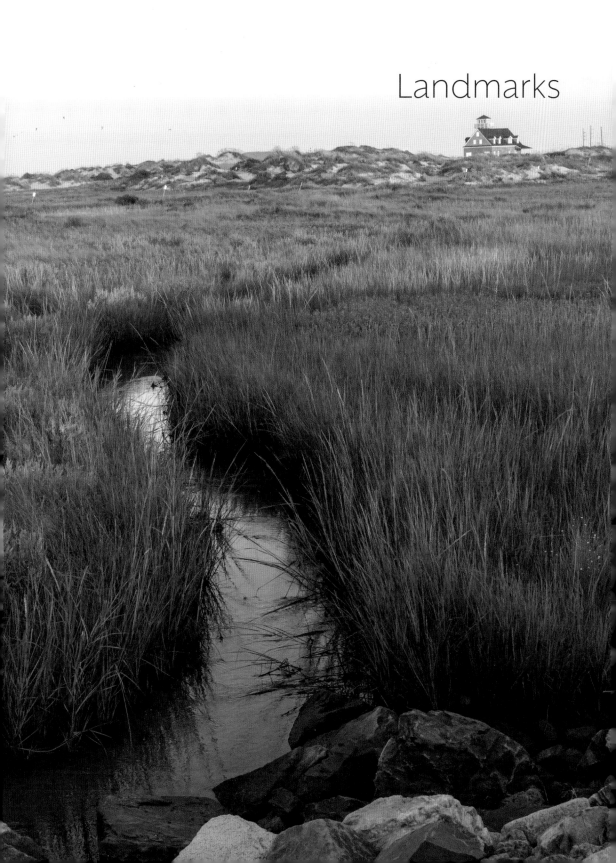

Landmarks

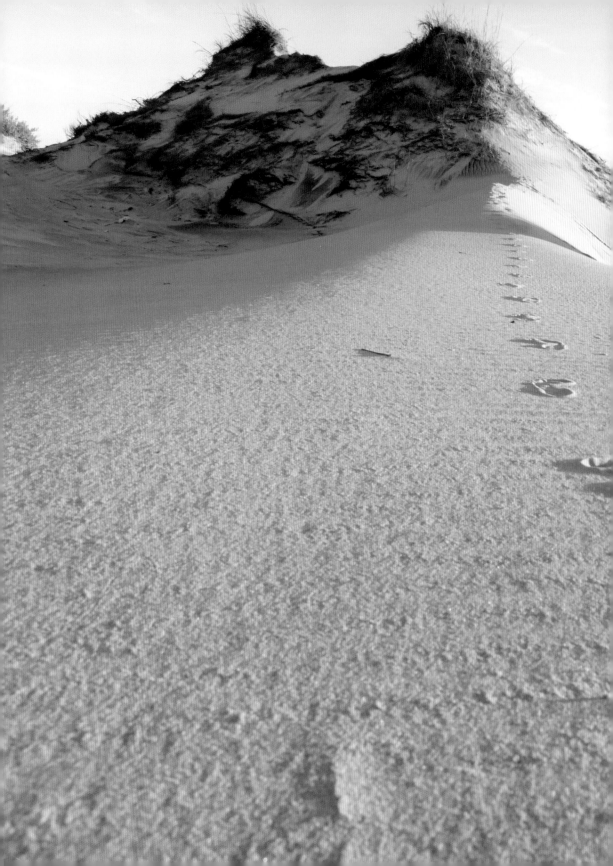

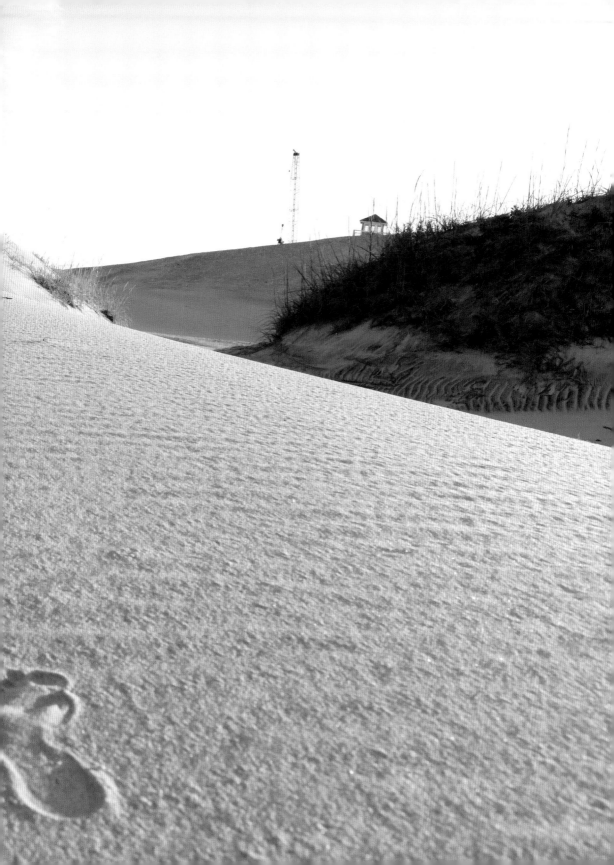

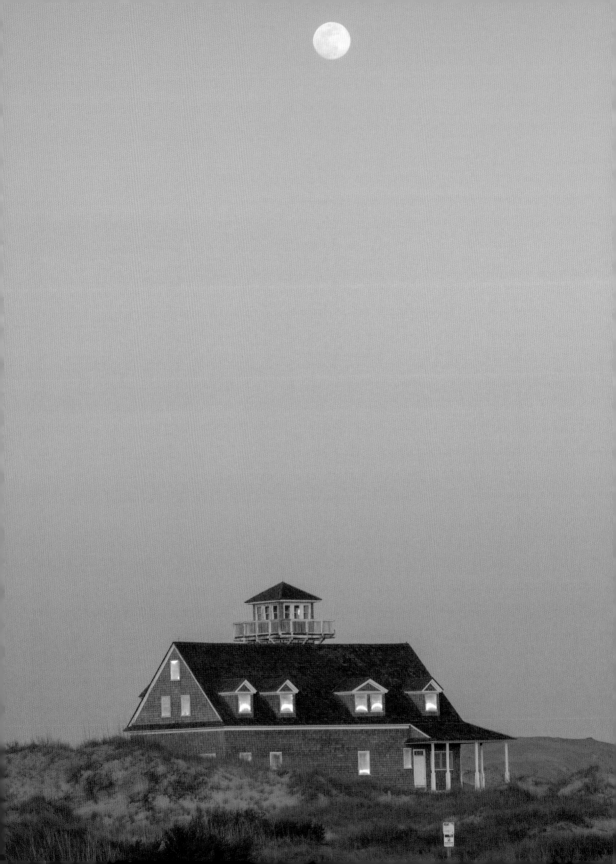

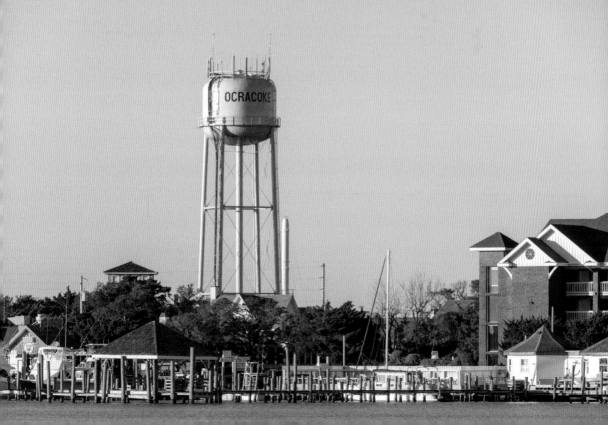

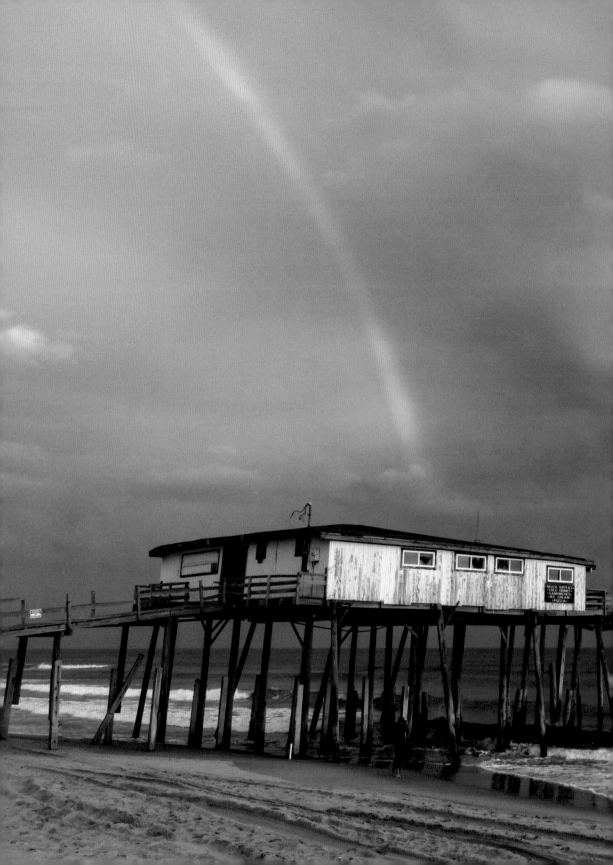

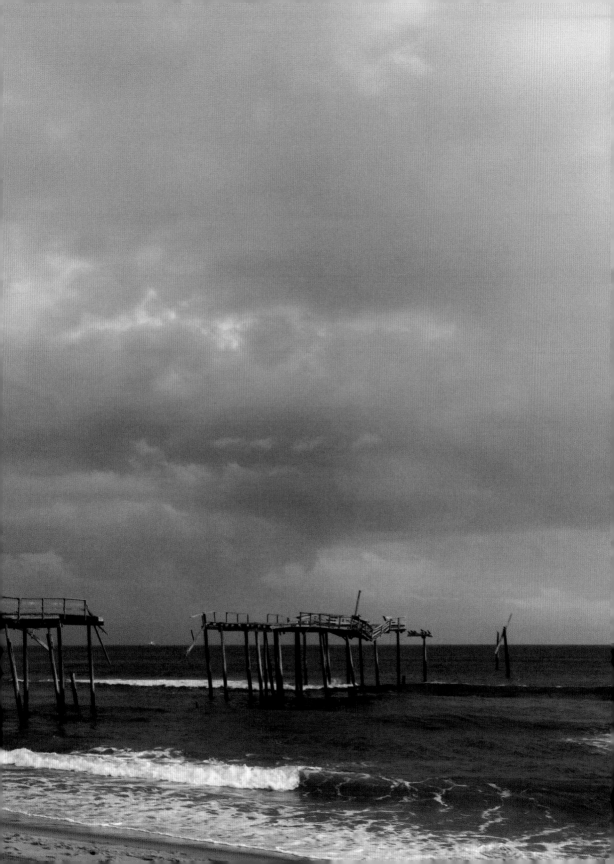

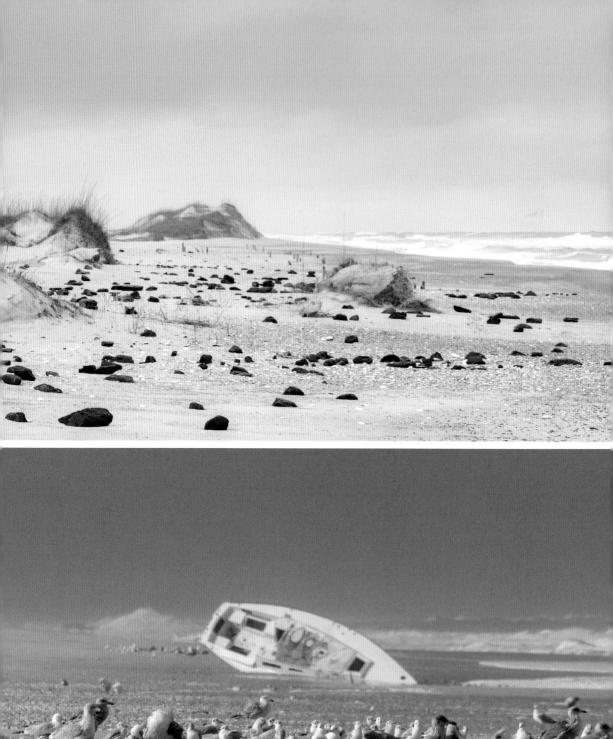

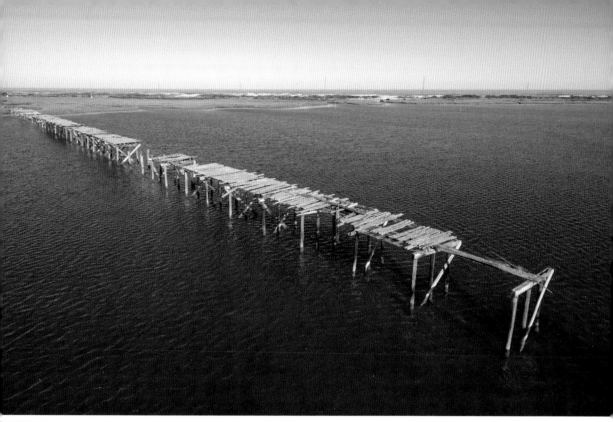

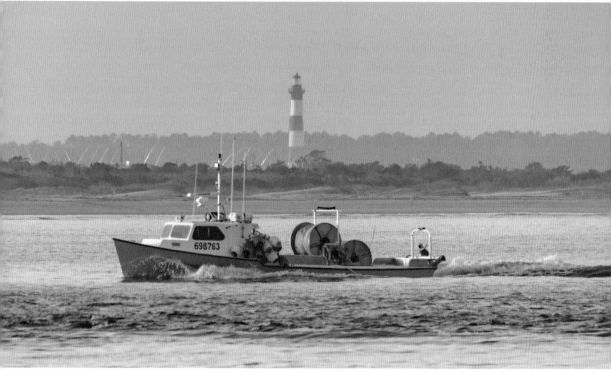

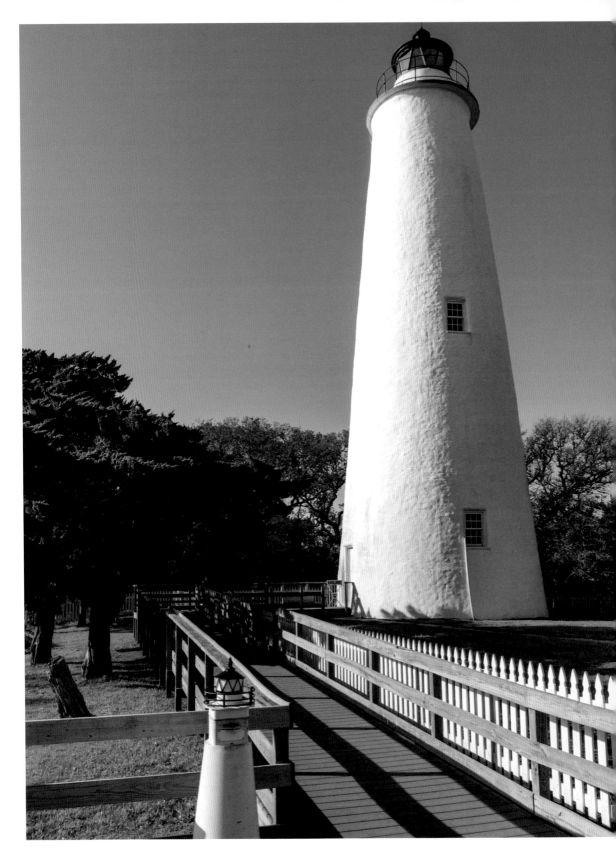

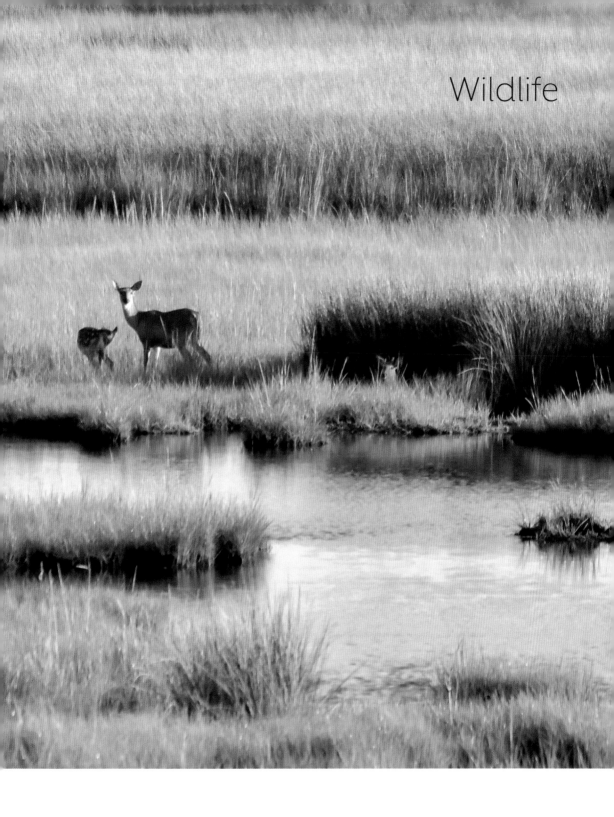

Wildlife

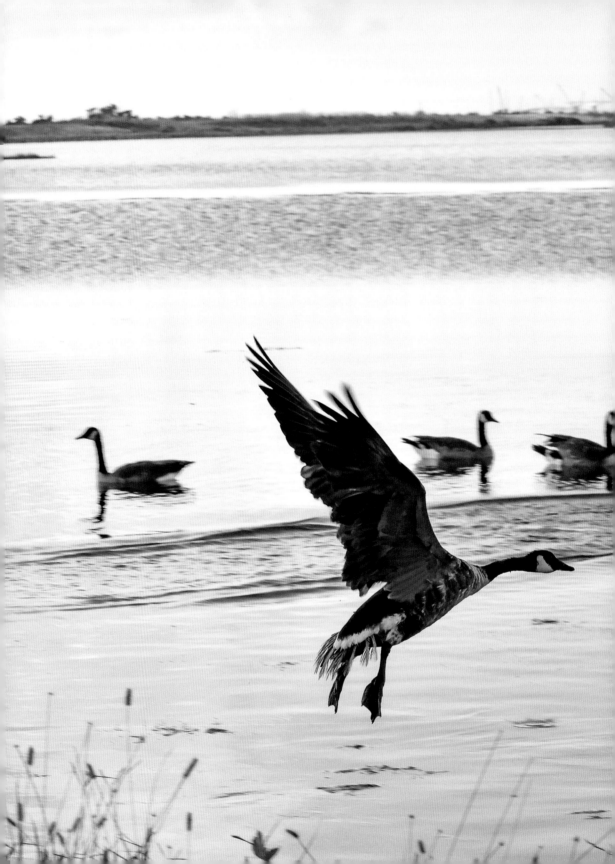

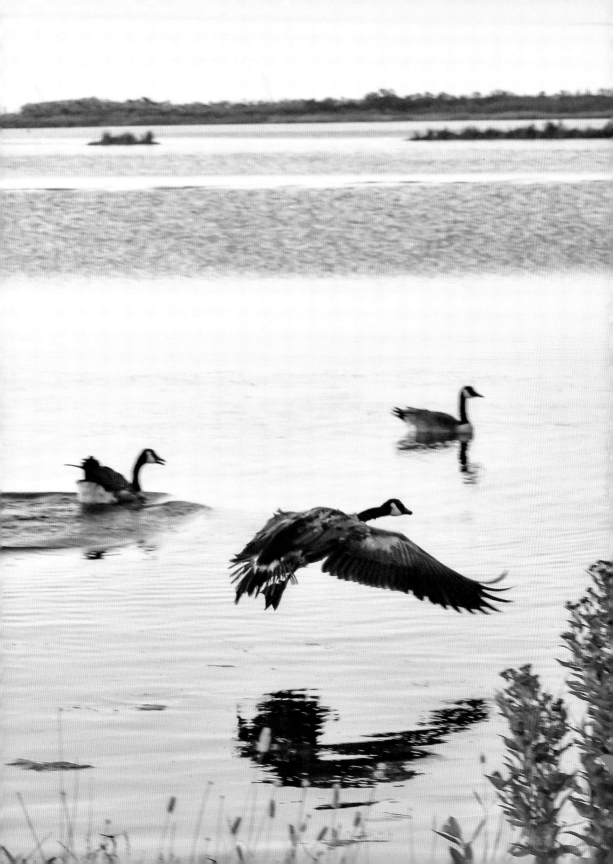

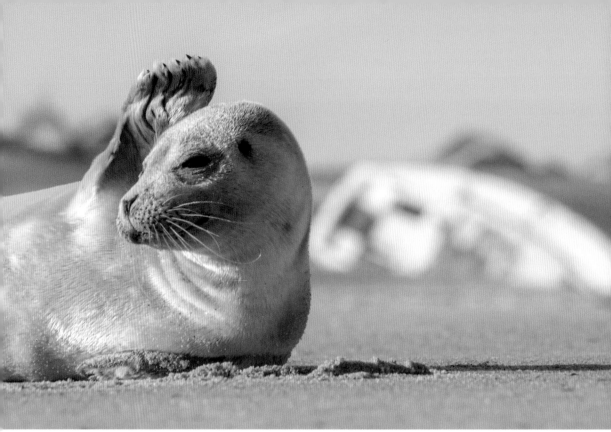

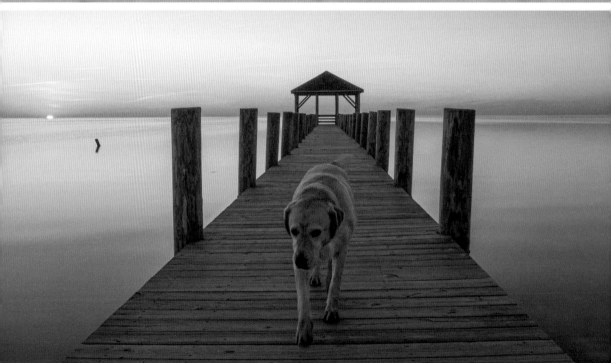

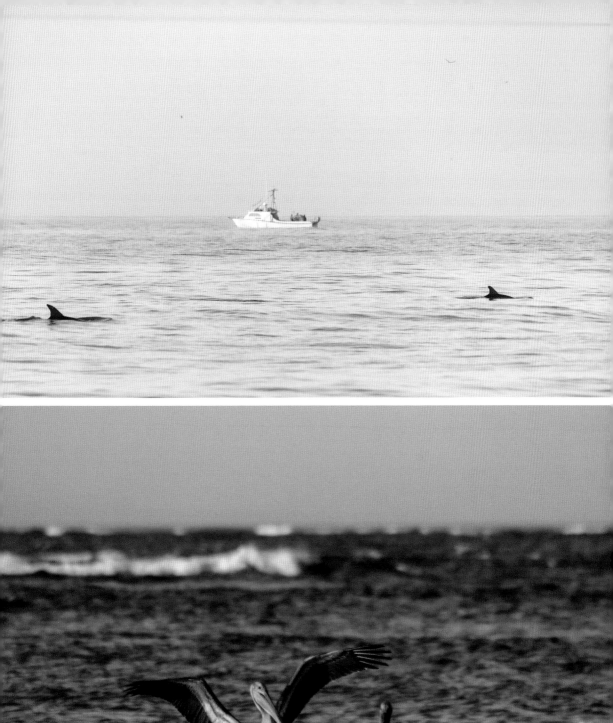

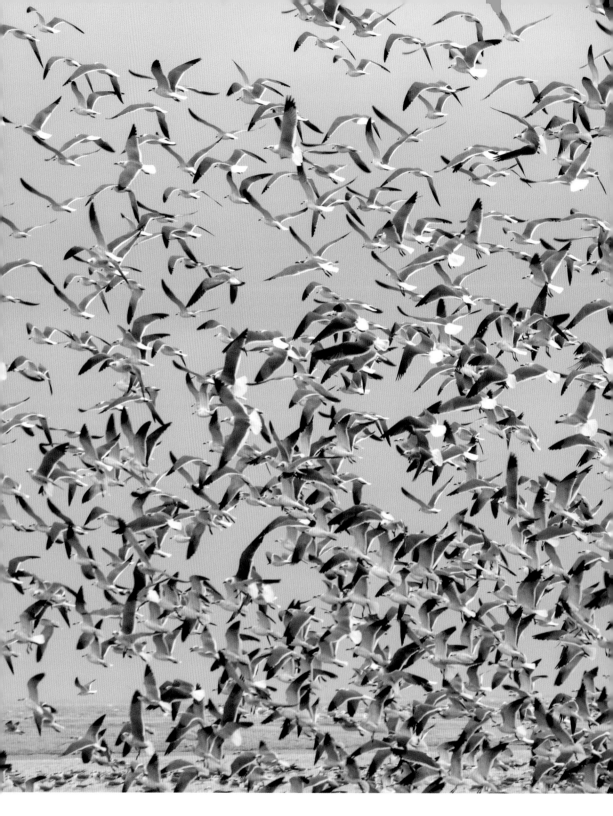

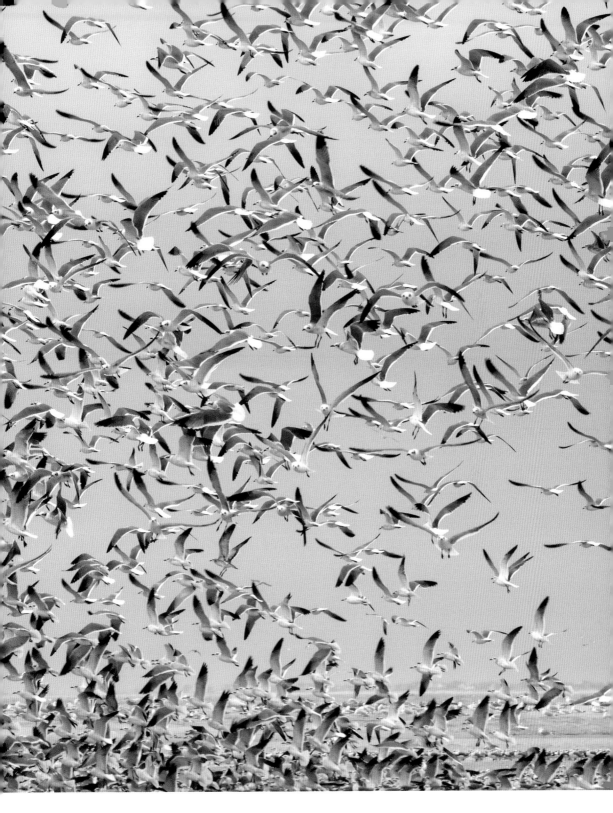

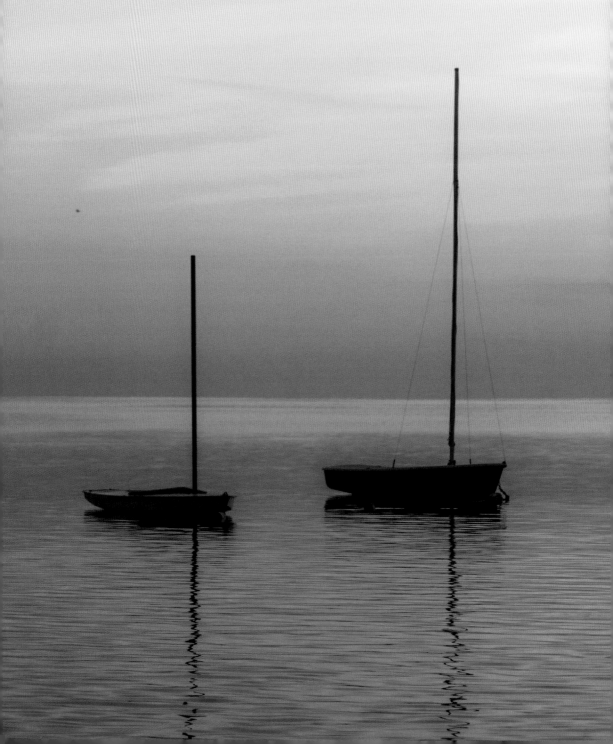

Sunrises/Sunsets

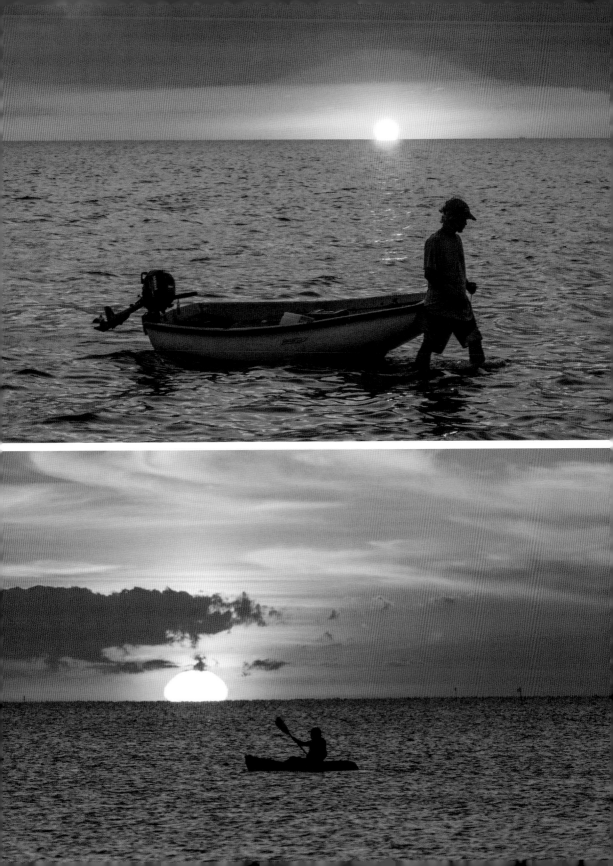

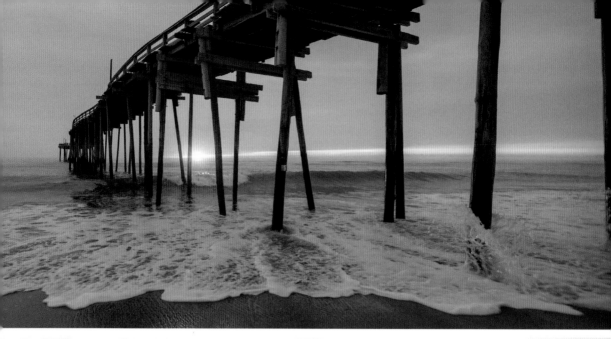

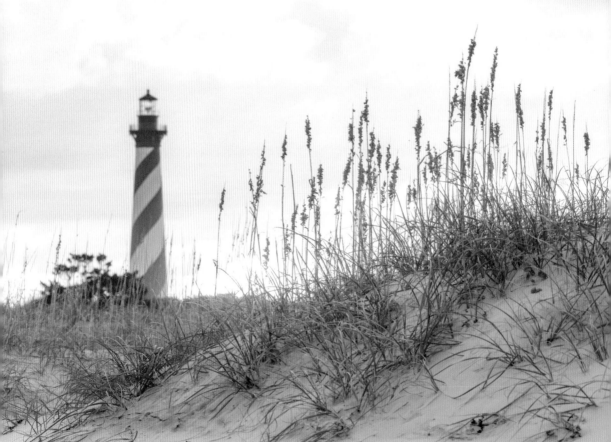

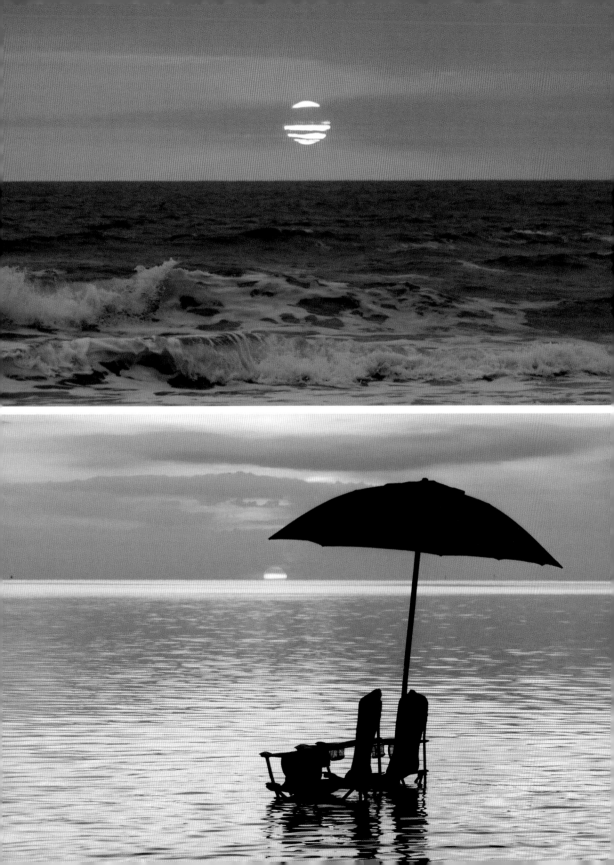

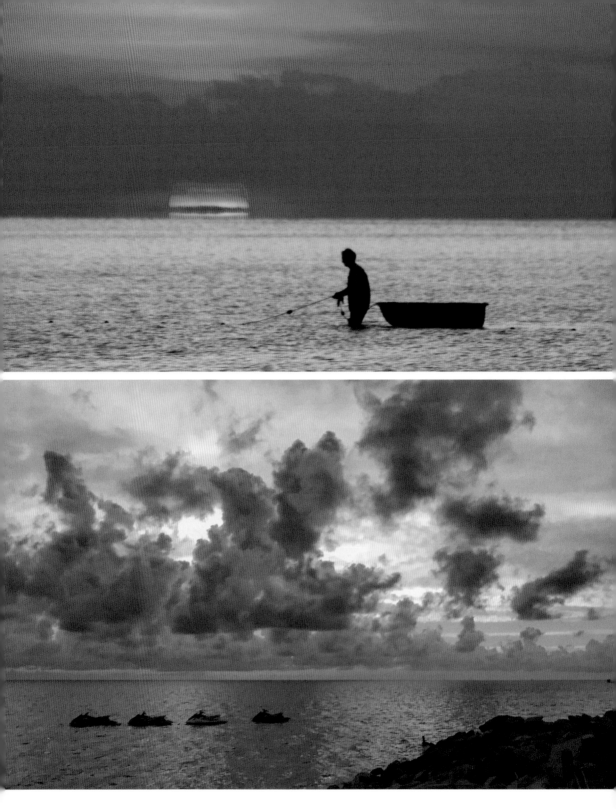

Night Sky

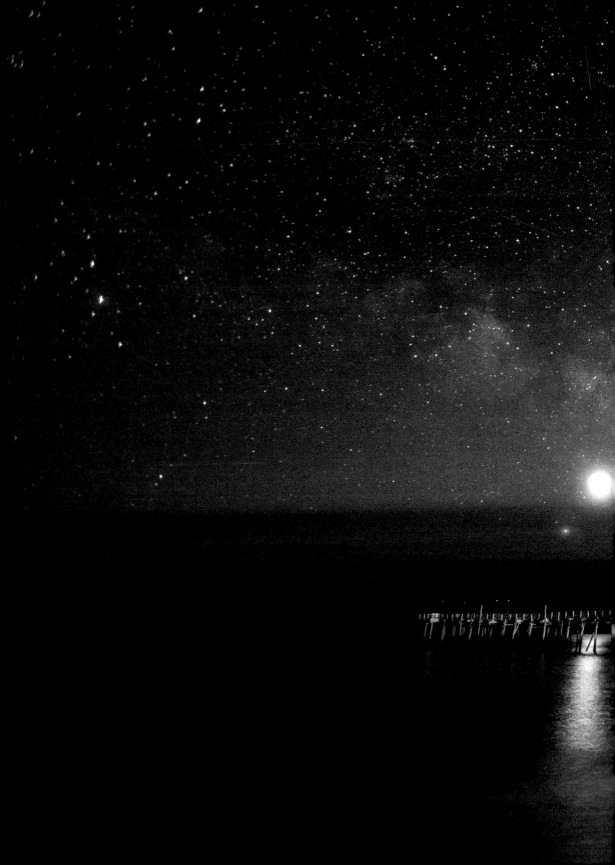

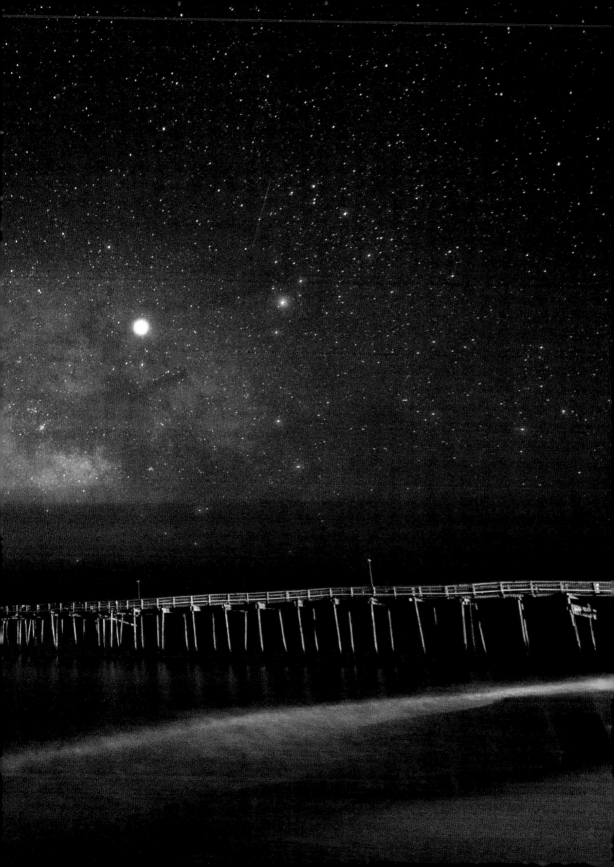

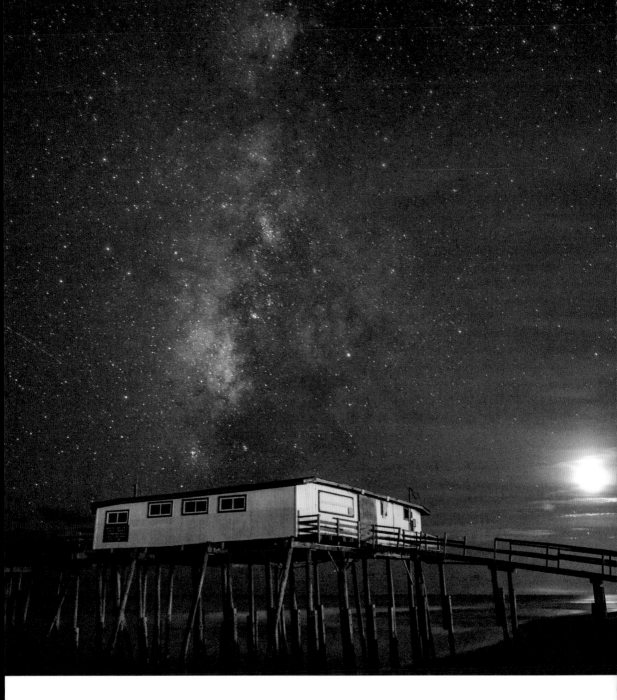

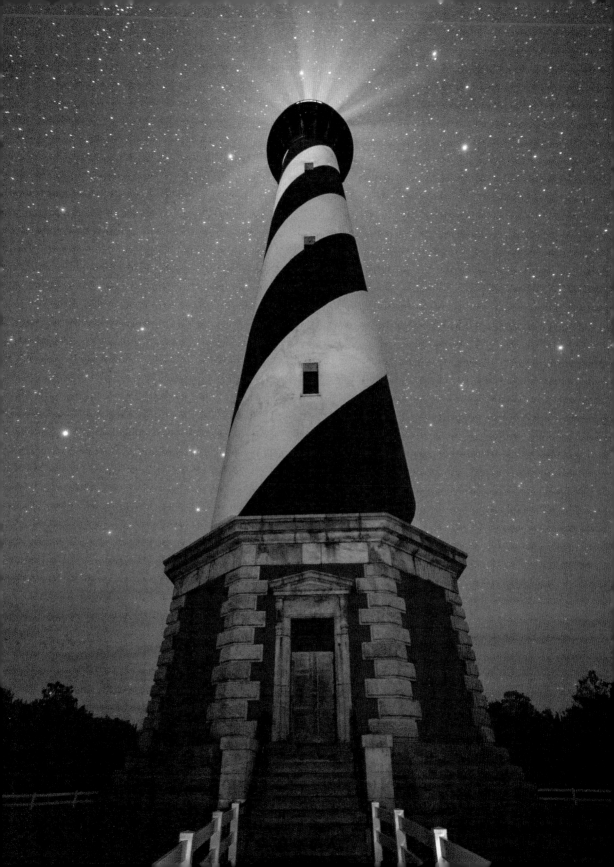

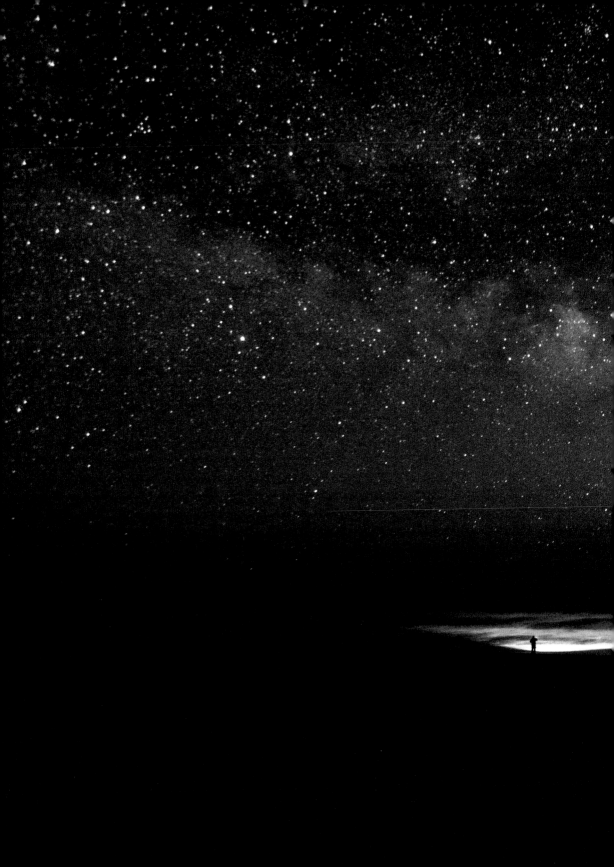

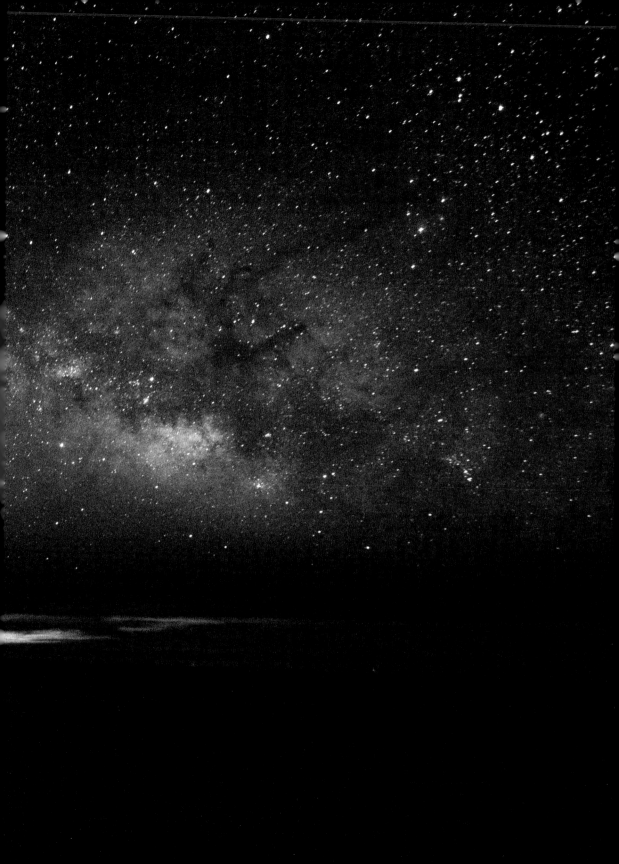

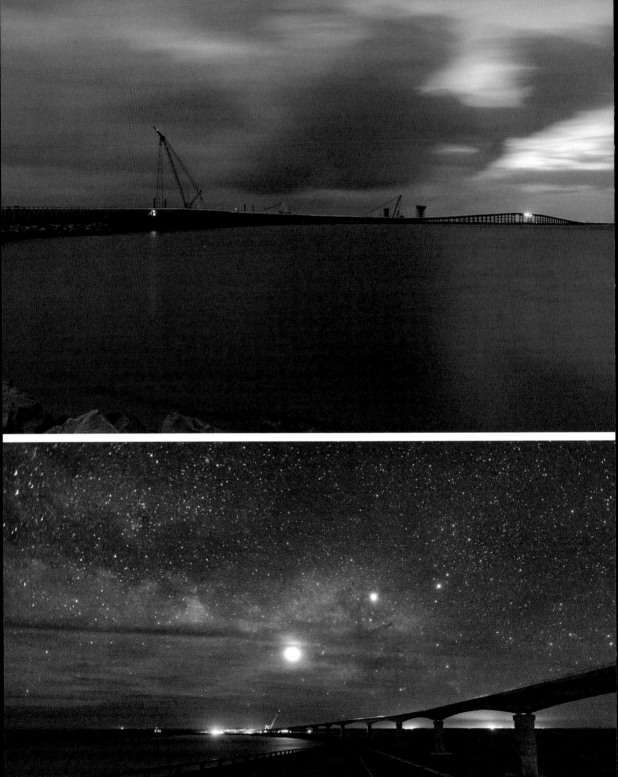

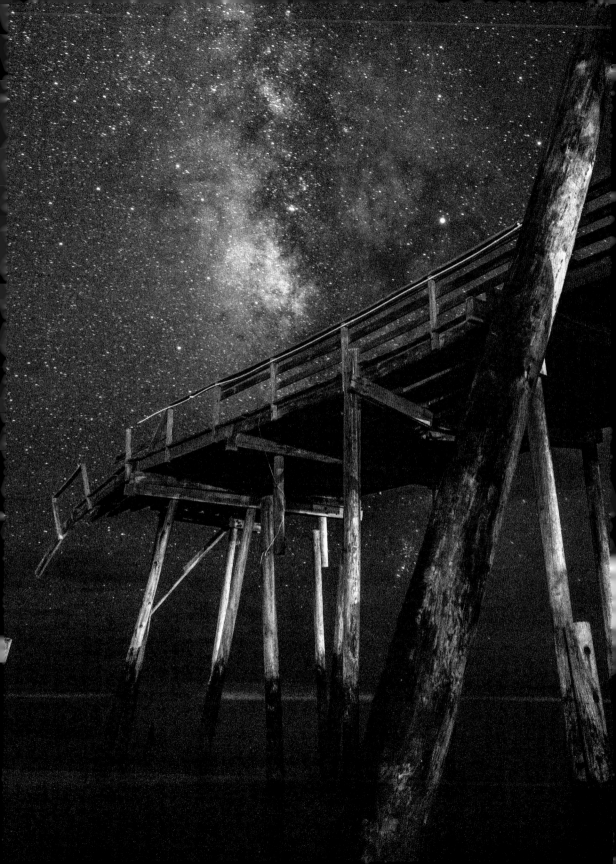

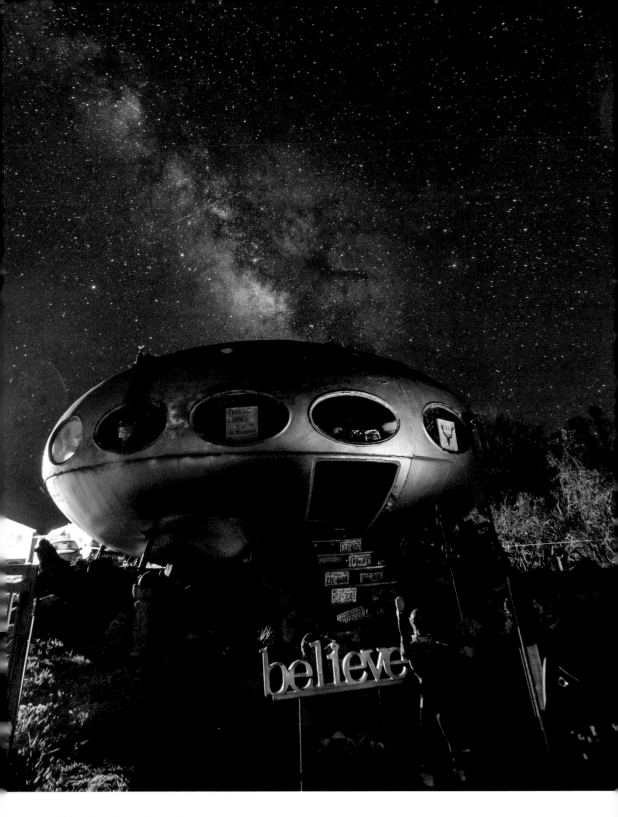

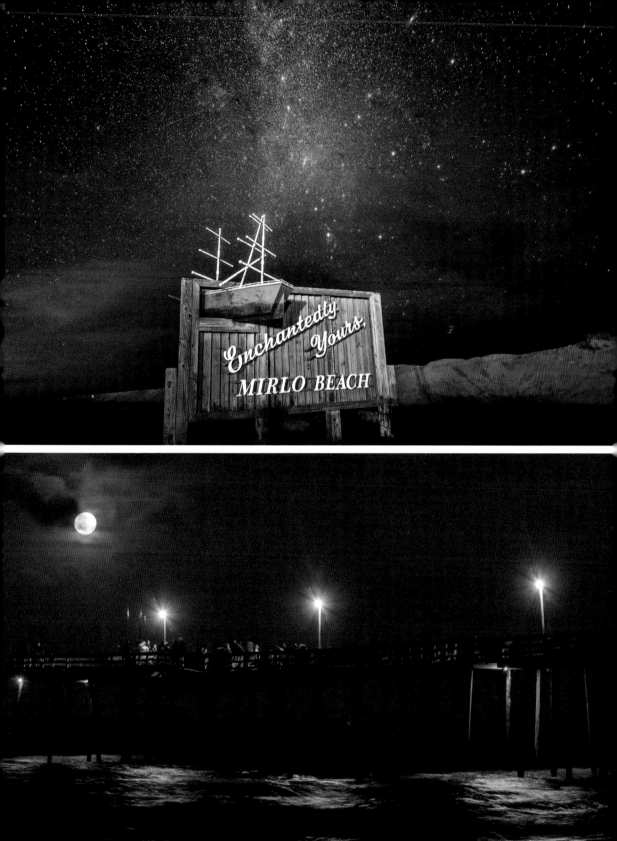

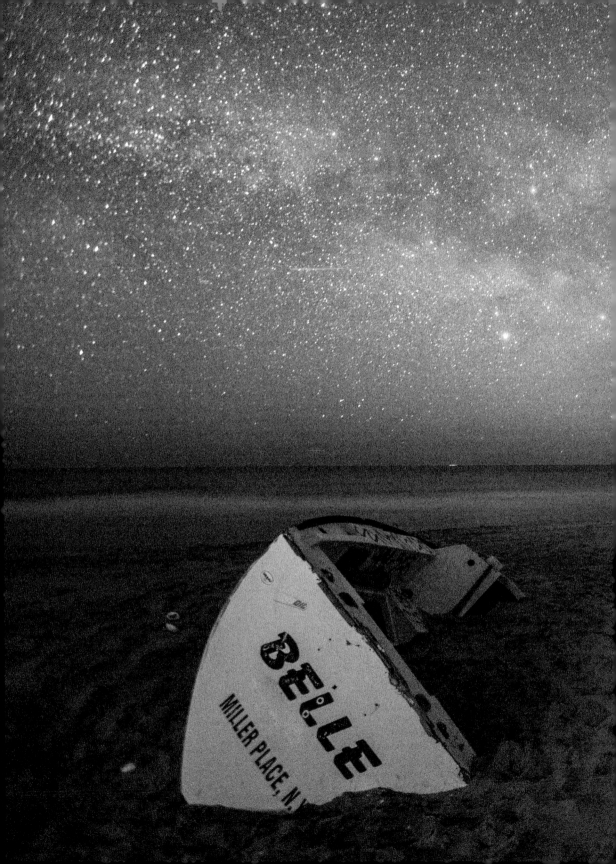

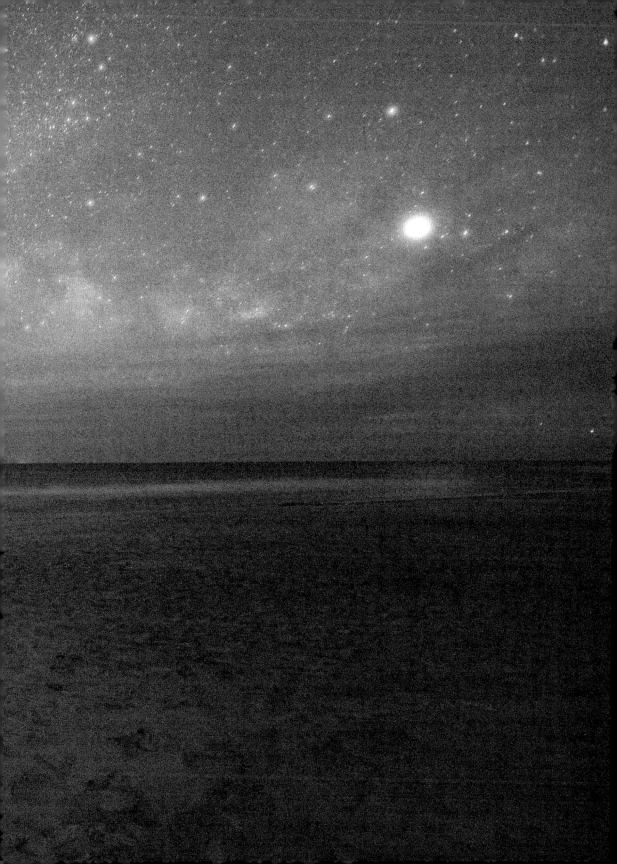

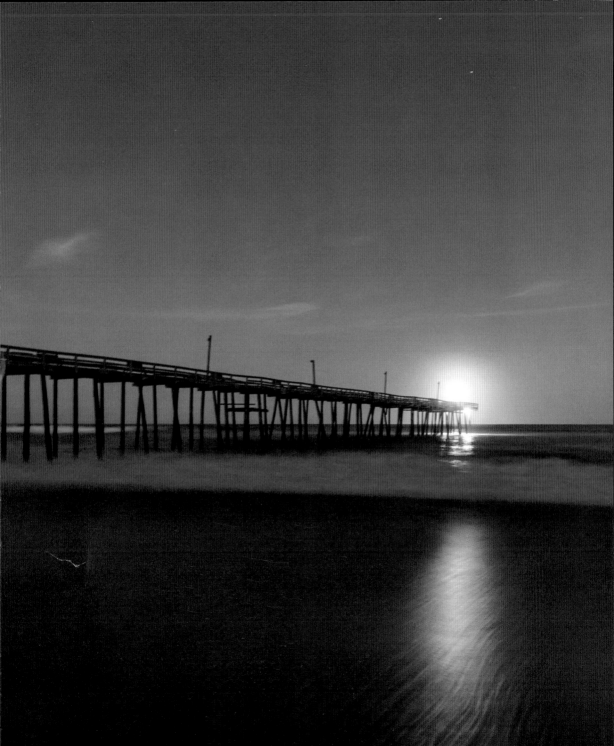

In August of 2016, I went tent camping in Rodanthe, NC. While camping, I watched and used my phone to capture pictures of a beautiful passing thunderstorm. It was then I decided I would buy my first camera to maybe someday do something in photography. I enrolled in two classes that fall to learn how to use my camera. In the beginning of 2017, I decided to make the leap towards my dream life of being a full-time photographer. I quit what I was doing, sold everything I could and relocated to the Outer Banks of North Carolina. At the time I only owned one camera, two kit lenses, and possessed only a little knowledge about photography. I hit the ground running with a deep desire to become a full-time professional photographer. Since moving to the Outer Banks I've spent every day capturing all of its beauty while teaching myself the wonderful art of photography.